WESTON-SUPER-MARE
THROUGH TIME
Stephen Butt

AMBERLEY

Acknowledgements

I am so grateful to the many friendly Westonians who have helped me retrace my steps in the town of my birth. These include the men watering the flower baskets in the Grove Park bandstand, the manageress of the Claremont Hotel, the reception staff of the Grand Atlantic Hotel and the lady behind the counter at the putting green station of the miniature railway on the beach lawns.

The photographers of the past found many curious and sometimes precarious locations from which to take their photographs, and I am therefore grateful to those owners and managers of properties who have allowed me access to their upper floors and windows.

I would also thank those who have provided information about specific photographs or locations. These include Dorothy Adams, Mary Beckett, Brian Cooper, Jean Jones, Mike Walker, Brian Airey of the Weston-super-Mare Family History Society, and Peter Lamb, Peter Davey and Marcus Palmen of the South Western Electricity History Society.

I'd like to thank my father, George Butt, for not only suggesting locations and telling me when I was pointing my camera in the wrong direction, but for being my guide, friend and inspiration throughout this project and its revisions in this edition. I would also like to record the valuable contribution of the late Stan Terrell who gave me access to his comprehensive postcard collection, and provided many historical facts and figures.

First published 2010
This edition published 2015

Amberley Publishing
The Hill, Stroud,
Gloucestershire GL5 4EP

www.amberley-books.com

Copyright © Stephen Butt, 2010, 2015

The right of Stephen Butt to be identified as the Author of this work has been asserted in accordance with the Copyrights, Designs and Patents Act 1988.

ISBN 978 1 4456 5202 3 (print)
ISBN 978 1 4456 5203 0 (ebook)

British Library Cataloguing in Publication Data.
A catalogue record for this book is available from the British Library.

Typesetting by Amberley Publishing.
Printed in the UK.

Introduction

The story of Weston-super-Mare is but a brief chapter in the long history of England. When Francis Knight wrote *The Seaboard of Mendip* he called Weston 'a town without a history'. At the time he was writing, at the beginning of the twentieth century, there were men and women of Knight's acquaintance who could still remember the local fishermen who had worked from Weston bay and who kept donkeys to haul their catch along the beach.

When his great antiquarian history of Somerset was published in 1791, the Revd John Collinson described this coastline of the fishermen as 'a flat sandy strand two miles in length to Anchor-head, at the west end of Worle-hill, which is another vast rocky eminence, and a remarkable object by sea and land'.

Where Weston-super-Mare now thrives, there was little except sand, dunes and the sea. It is perhaps the stone of Weston, solid grey limestone hewn from the quarry below Worlebury, which gives the town an appearance of longevity. A visitor to Grove Park or the Shrubbery, or South Road, or the little streets between High Street and Orchard Street will see a townscape which should be much older. Somehow, the feel of the place is much more than something created to entertain the Victorian elite and later, courtesy of the railways, the first holidaymakers.

But of course there certainly was an earlier Weston. It was not a seaside resort, but a small settlement of cottages nestling in the shelter of the hill and in the shadow of a parish church which dated back to at least the thirteenth century. Why did Weston-super-Mare grow so dramatically during the nineteenth century? It was certainly due to the technological advances of the Victorian age which enabled the railways to connect the industrial inland towns with the coast. It was also due to the social enlightenment which was to make available the invigorating air of the seaside to the masses who worked in factories as well as to the elite. And locally, there was the management and ownership of land.

The Pigott family of Brockley acquired the manor of Weston in 1696 and held it until the outbreak of the First World War. In 1808, the Pigotts sold off the ancient Auster tenements, the old huts of the fishermen and their plots of land, which paved the way for the Weston Enclosure Act of 1815.

Two men bought much of the Auster property, Richard Parsley and William Cox, and they were the first of a line of entrepreneurs who were to influence greatly the future of the town.

My grandfather was Henry Butt, but not the Henry Butt who was Weston's first mayor. Grandfather did bump into his namesake once. The exact dialogue has been lost in the mists of time but followed the lines of:

'Do you know who I am, my man?'

'No?'

'I am Henry Butt.'

'Well, so am I. Pleased to meet you.'

At which point my grandfather shook the mayor's hand, and they parted, one with slightly less wind in his sails. My great-grandfather on my mother's side, the Revd Alexander John Woodforde, served briefly as a curate at the Parish Church of St John, at which time he lived at Chittagong Villa in Shrubbery Walk. He was later vicar of Locking. He painted a number of watercolours of Locking church and vicarage which are treasured family possessions, but as yet no paintings by him of Weston have come to light.

So we need to draw upon photography for a record of Weston in the past, including the commercial photographers of the Victorian and Edwardian age, and the gifted amateur photographers of later decades when lightweight cameras and relatively inexpensive film came onto the market.

The images in this volume record both change and the fact that some buildings and locations seem never to change. My own perspective is of someone who was born and bred in the town, went away and came back, and so I remember the landmarks of my childhood and see very readily how they have survived or sometimes disappeared; but we all have our own history, and we each will have a different Weston in our memories to recall and savour.

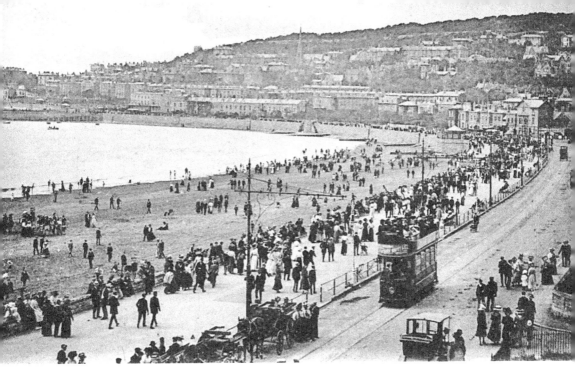

Weston-super-Mare Bay
The curve of Weston's bay looking north towards Worlebury from the Grand Atlantic Hotel. Arguably the resort's finest asset has been its promenade and sea wall of 1887, which was imaginatively renewed in Weston's twenty-first-century flood defence project.

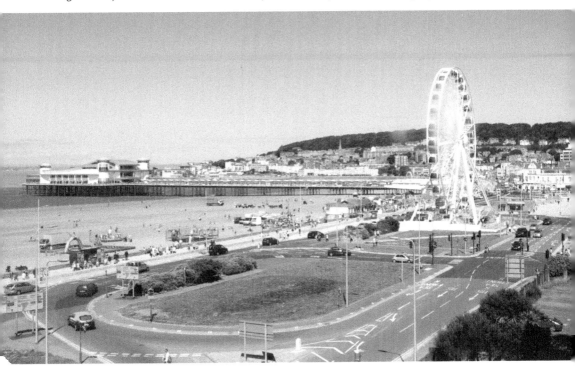

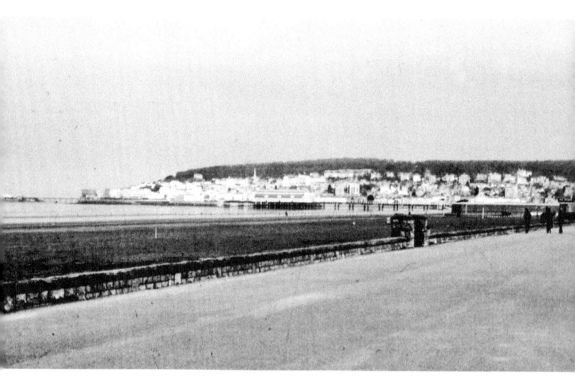

The Promenade
A comparison of the original Victoria sea wall and esplanade, constructed in 1887, and the twenty-first-century sea defences, looking north from near the former Sanatorium.

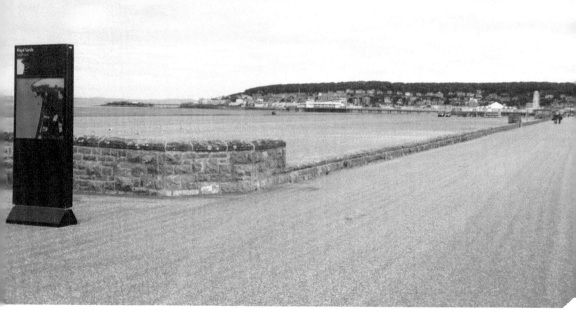

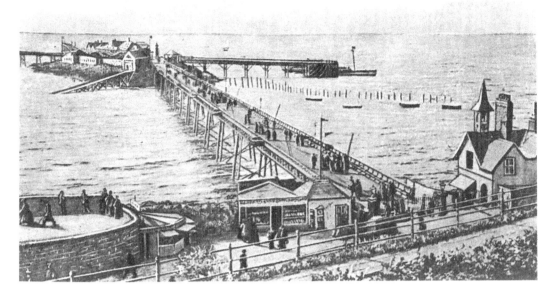

Birnbeck Pier

Engineered by the great designer of seaside piers Eugenius Birch, Birnbeck Pier was opened on 6 June 1867. It is the only pier in the country to link the mainland with an island. The celebrated local architect Hans Price designed the pier head buildings. Despite its heritage, this important structure, in 2015, is decaying and neglected.

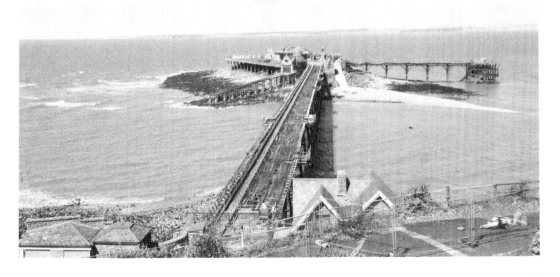

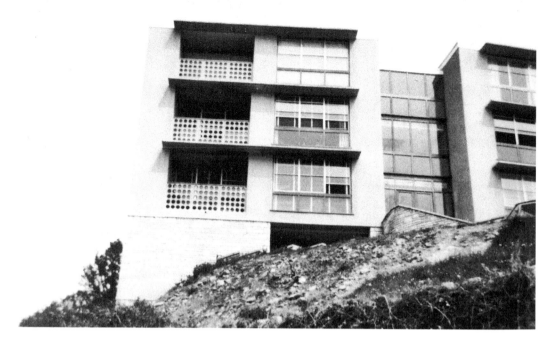

Residential Apartments – Kewstoke Road
On the western edge of Worlebury Hill, residential properties, in many styles, overlook Birnbeck and the Bristol Channel reflecting the architectural styles of their time. This block was constructed in the early 1960s. The stark design has softened and weathered over the past fifty years.

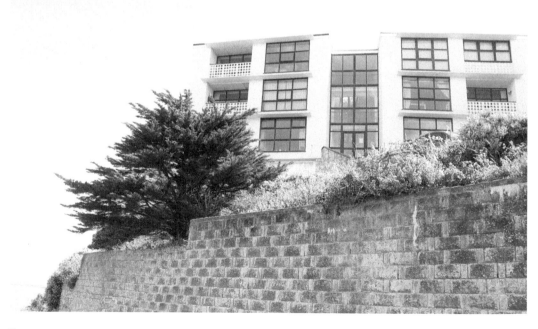

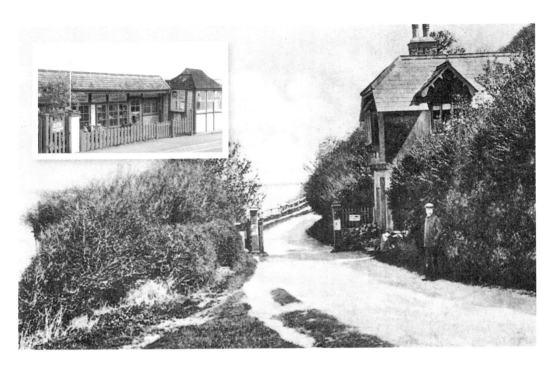

Kewstoke Road Toll Gate

Arthur Mee wrote, 'the finest thing that Weston has ... is the drive to Kewstoke through the woods'. This meandering road around the edge of Worlebury Hill, connecting Weston with Kewstoke, was part of the former Smyth-Pigott estate, so retained the status of a private road on which a toll could be levied. The toll gate opened in 1848. Tolls ceased in 2004 when safety measures were put in place following a number of fatal road traffic accidents.

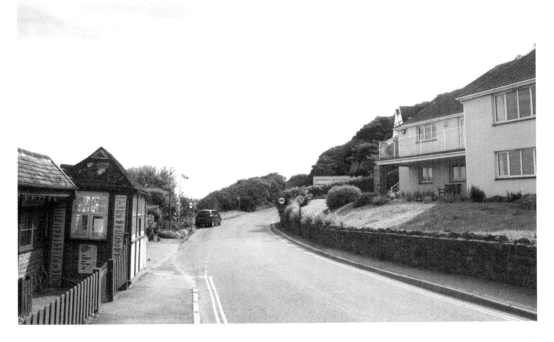

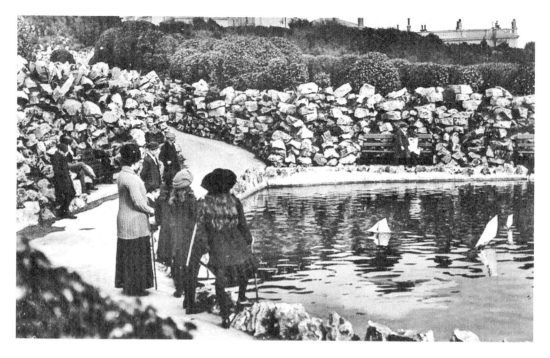

Prince Consort Gardens Boating Pool
Overlooking Birnbeck Pier, on what was then a bare windswept hillside known as Flagstaff Hill, these gardens were handed over for the free use of the public in 1883 by Cecil Hugh Smyth-Pigott, and were laid out in the 1860s in memory of Prince Albert. The lower triangle, now a car park, contained the Flagstaff which was often used to alert coastguards to smuggling activity off the coast.

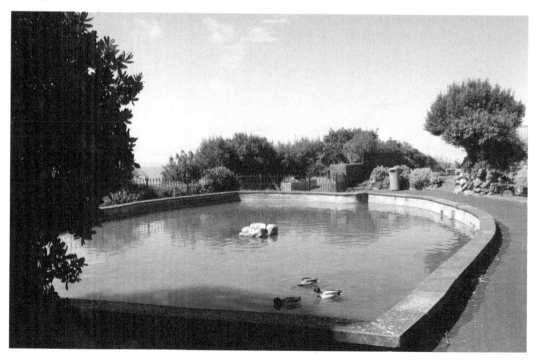

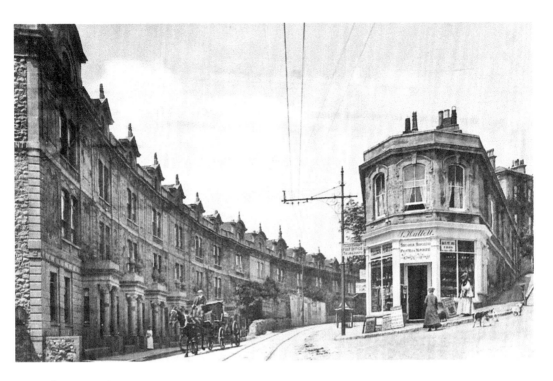

Claremont Crescent
This older photograph can be dated precisely. A placard outside the corner shop announces, 'Ascot Centenary Gold Cup Stolen'. This notorious theft took place on 18 June 1907. Perched between Claremont Crescent, Madeira Road and Kewstoke Road, this shop still sells daily newspapers.

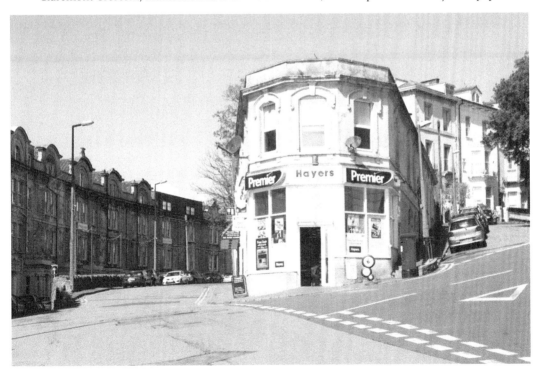

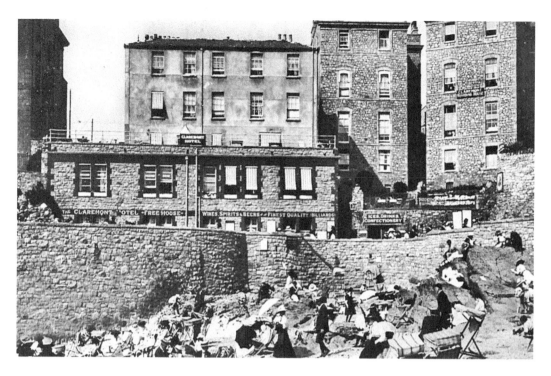

Claremont Hotel and Anchor Head

Overlooking an ancient fishing location, and one of the earliest places where pleasure steamers could berth, the Claremont terrace was built in the 1860s. The height of the sea defences is echoed in the buildings in this area which also represent the town's growing confidence and prosperity after the railway arrived in 1841.

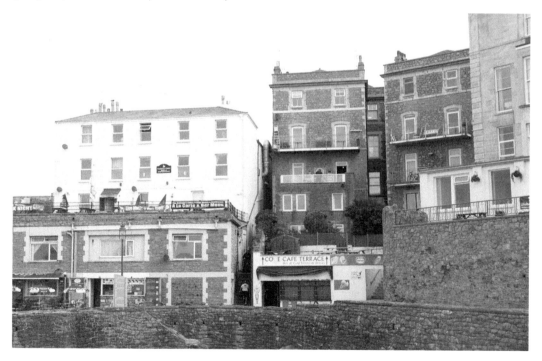

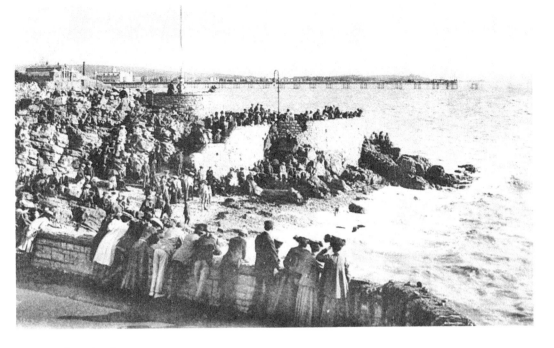

Anchor Head

Long before Weston came into being, the sea crashed onto these rocks at high tide. The Victorian engineers made it more accessible, even for ladies in long skirts! In 1791, Collinson, in his *History of Somerset*, wrote that 'northward from Uphill is a flat sandy strand two miles in length to Anchor-head, at the west end of Worle-hill, which is a ... vast rocky eminence, and a remarkable object by sea and land'.

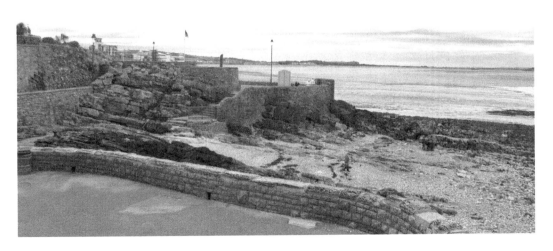

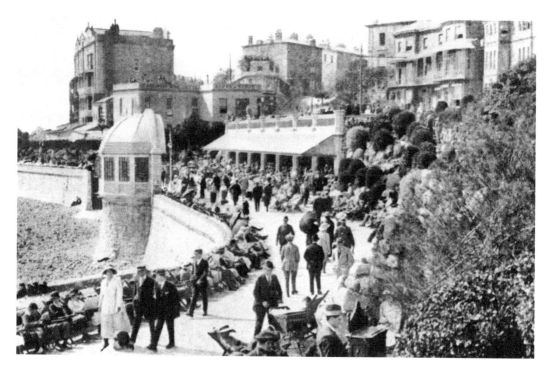

The Rozel and Madeira Promenade

There have been a number of shelters and structures on this site. The Dutch Oven Bandstand on the seaward side was built in 1920. The conductor had to remain outside the shelter even when it was raining. No charge was made to those who stopped to listen to the music, but a collection would be taken.

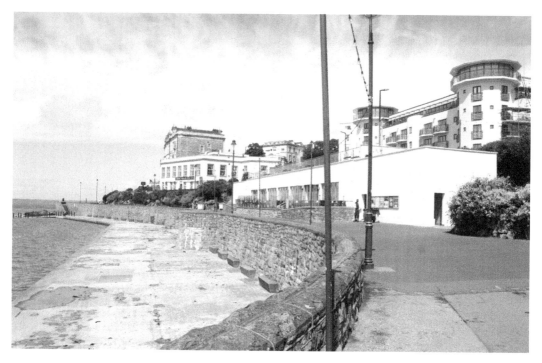

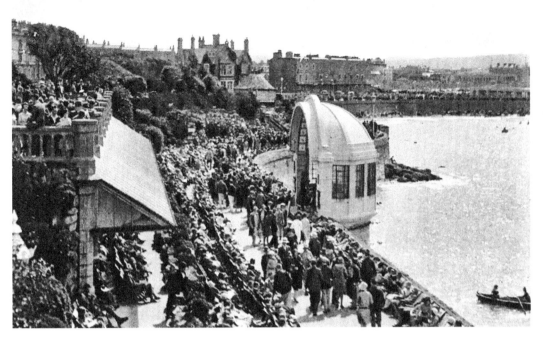

The Rozel and Dutch Oven Bandstand
A view from Madeira Cove of the
Rozel area and the curious bandstand
perched on the very edge of the
promenade. The modern apartments
above are Rozel House, an imaginative
design by Brandwells of Bristol on the
site of the former Rozel Hotel.

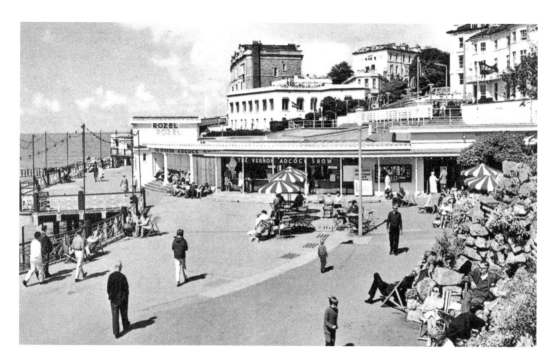

The Rozel Bandstand and Music Gardens

The Rozel was built in 1937 and was very popular with holidaymakers. For many years the resident band was led by the late Vernon Adcock. Traditionally, he opened his shows with 'Spread a Little Happiness'. Formerly a solo xylophonist, Adcock was a talented jazz musician and, in the words of Ken Rattenbury, the band's pianist, 'a great gentleman and a joy to work for'. The Rozel area was redeveloped after major damage in the gale of 1981.

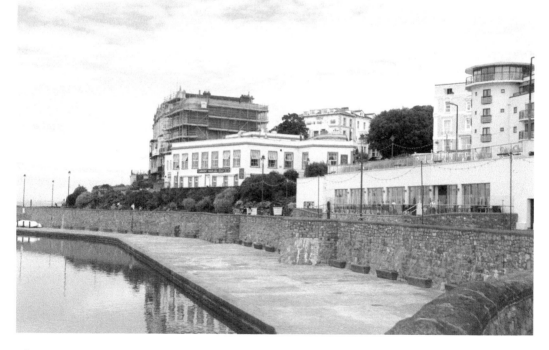

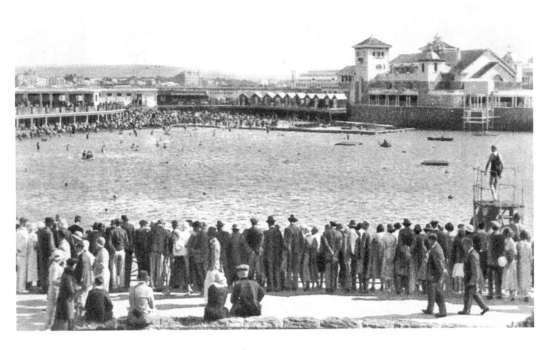

Marine Lake from Madeira Promenade
The Marine Lake was created in Glentworth Bay in 1929 when the causeway was built linking the headland just south of Anchor Head with Knightstone. In its heyday, this was a 'resort within a resort' with family entertainment and food provision in a safe and comfortable environment. A concrete extension at promenade level was later added, which was damaged beyond repair by the storms of 1981.

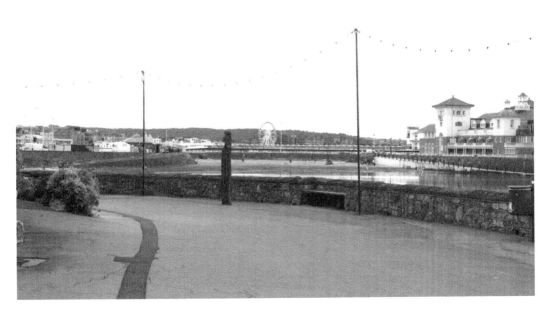

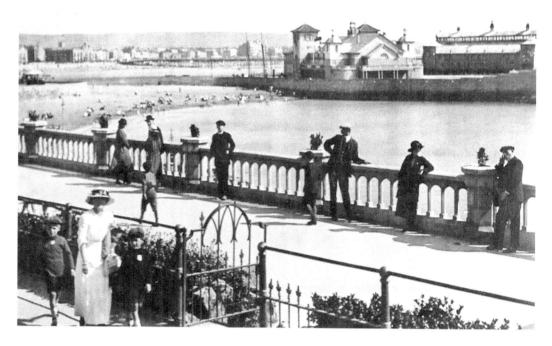

Knightstone from Madeira Cove

There is a mood of peace and elegance in the manner in which the people in the foreground in this early photograph are 'taking the air'. All the informality, fun and games appear to be taking place across the bay. The masts of a sailing vessel can be seen at the jetty at Knightstone. *Ward-Lock's Guide* states that Glentworth Bay is 'the part most favoured by better-class visitors. Here there is less "fun" than on the more open reaches farther south.'

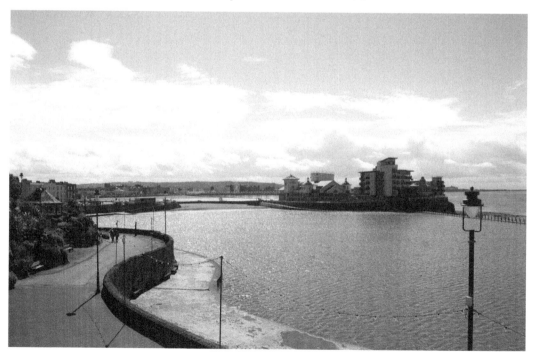

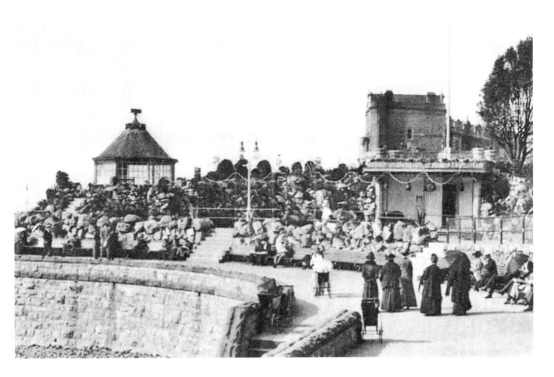

Madeira Cove

The Victorian engineers made fine use of the natural landscape here to create a succession of paths, gardens and shelters from which the entire length of Weston bay across to Uphill could be seen. A renovation project began in 2010, led by artist Tania Kovats, which has included the planting of many maritime species reflecting the natural flora of the area.

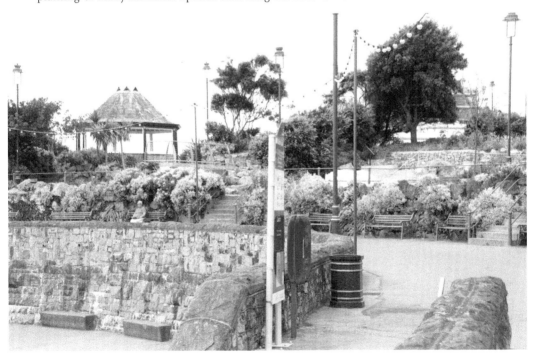

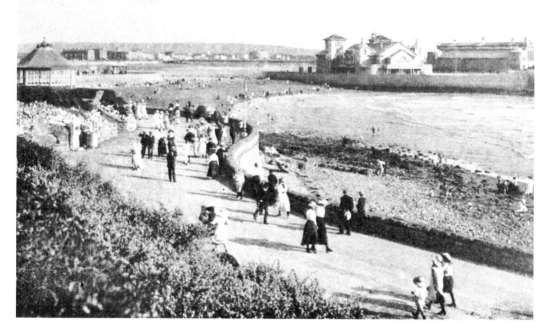

Knightstone from Madeira Cove
The first Knightstone buildings – the pavilion and the baths – opened in 1902, and in this early view from Madeira Cove, the Marine Lake has yet to be constructed. The new buildings on Knightstone have successfully added shape and style to this familiar skyline.

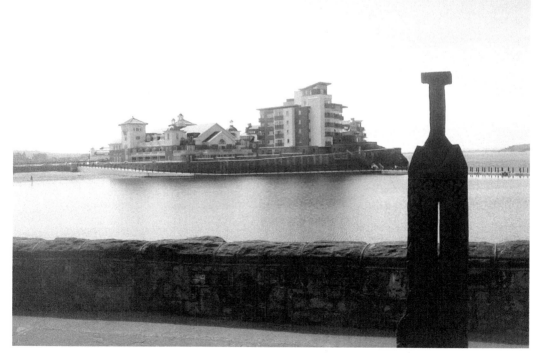

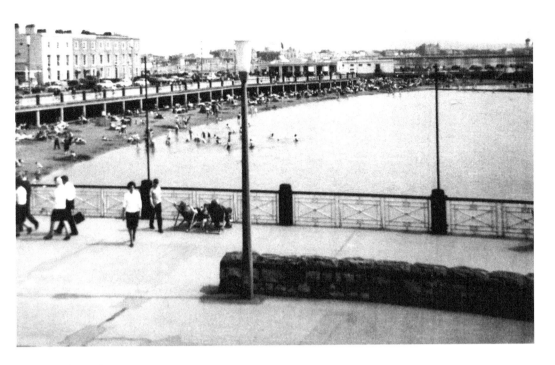

Marine Lake
The Marine Lake is perhaps the most-remembered aspect of many holidays taken in Weston-super-Mare after the Second World War when railway excursions to the resort from London and Birmingham made outings to the seaside possible for many thousands of working-class families. The promenade extension can be seen clearly in the older photograph.

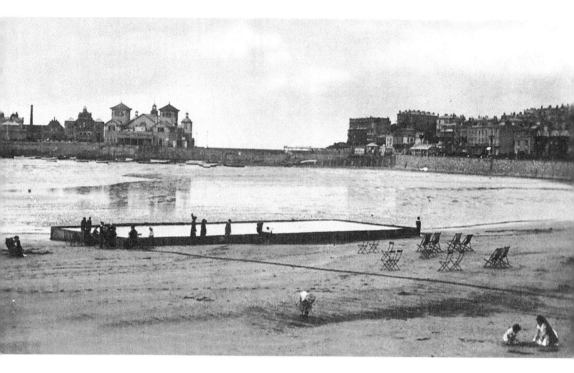

Towards Knightstone and Worlebury
On the slopes of Worlebury Hill stand the impressive terraces of houses which date from the mid-nineteenth century, overlooking Knightstone and the grand sweep of the bay. Hunt's Directory of the 1840s said of the town, 'its hillsides are studded with temples of health and mansions of the rich'.

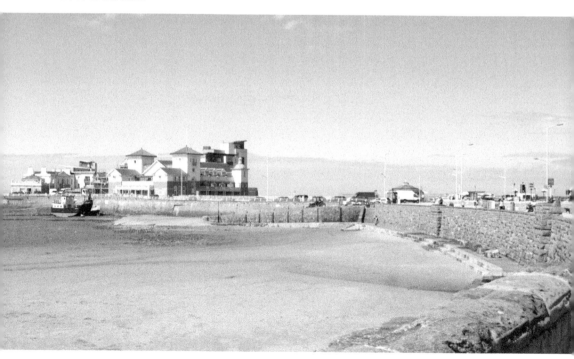

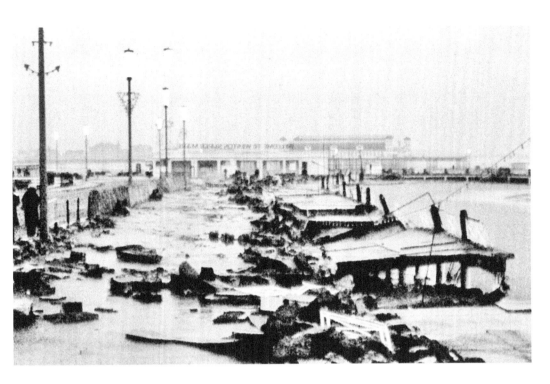

Marine Lake Promenade
The promenade suffered major gale damage in the storm of Sunday 13 December 1981. This photograph was taken on the following day. The entire section was later removed (*inset*) and, in 2010, the promenade was completely renewed as part of the town's flood defence project.

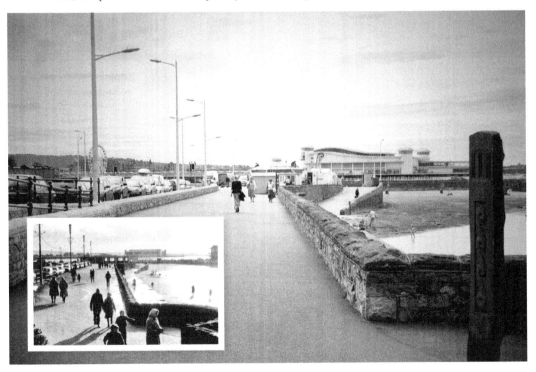

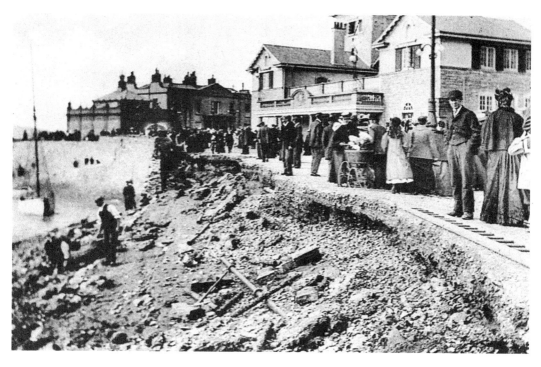

Knightstone – The Great Gale of 1903

Westonians can never forget that the sea can bring danger and devastation as well as enjoyment and prosperity. In the Great Gale of 10 September 1903, little more than a year after the opening of the pavilion, the approach to Knightstone fell away.

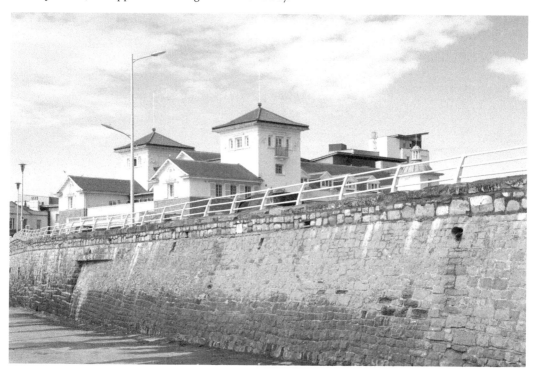

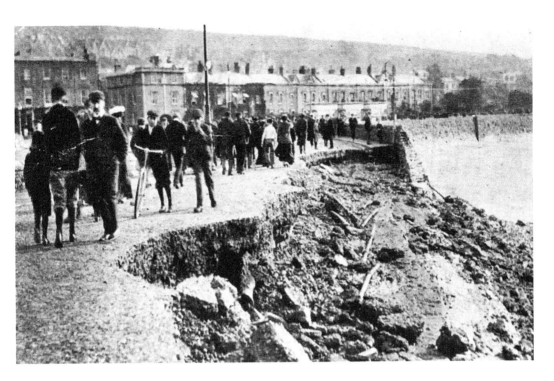

Knightstone – The Great Gale of 1903

Another view of the damage to the causeway at Knightstone. Today, at least three different phases of rebuilding can be seen in the retaining wall. A guide book of 1822 speaks of Knightstone as being 'joined to the village by a bank of pebbles thrown up by the sea'. Three of Weston's eighteen trams were ruined in the storm.

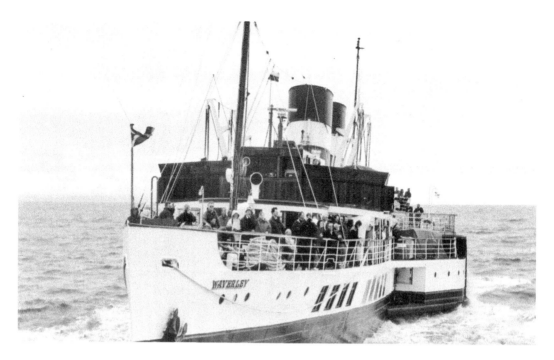

Knightstone Jetty

Vessels have moored at Knightstone since before Weston was born. By the 1820s, local fishermen were offering their boats for pleasure trips, and after the town had been connected to the railway network, steamers began to stop here too. In this photograph taken in the 1980s, the SS *Waverley*, the last surviving ocean-going paddle steamer, prepares to depart. Pleasure boats still operate from this jetty.

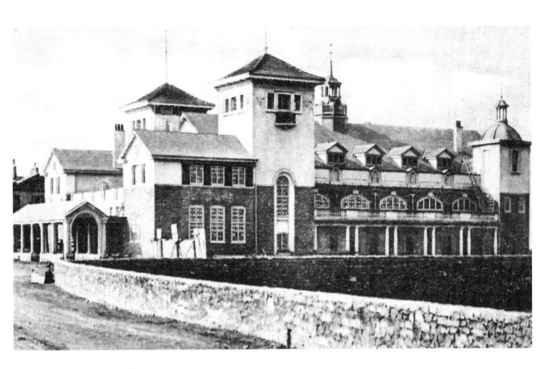

Knightstone Pavilion

The pavilion opened in 1902 and was designed and built by the London architect J. S. Stewart. It was a fine example of an all-purpose hall providing a wide range for holiday entertainment. It served as a battledress factory during the Second World War, reopening in 1942. In recent years, the Pavilion and adjacent baths have been converted into apartments in a project which cost £20 million.

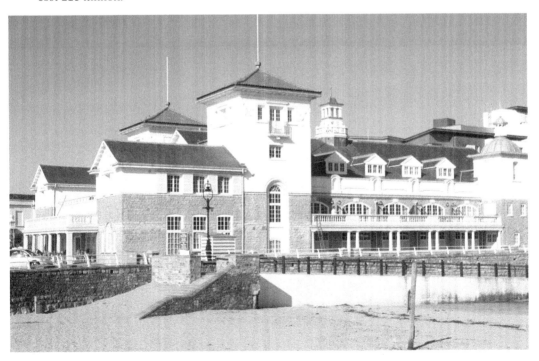

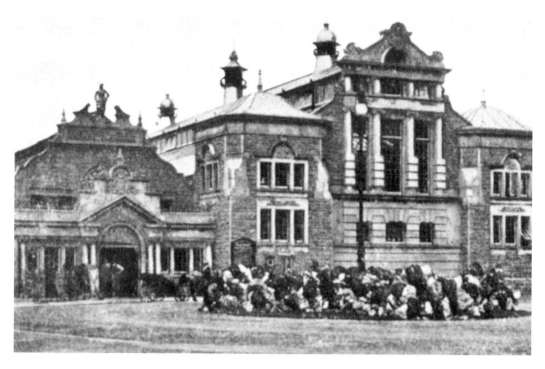

Knightstone Baths

The first bath house and pool at Knightstone opened in 1822, offering a variety of hot and cold facilities with medicinal benefits. Dr Edward Long Fox built a new bath house in 1832, the frontage of which can still be seen. The larger Edwardian baths were built in 1902 to the side of Fox's baths. A listed building, it is now part of a modern residential centre.

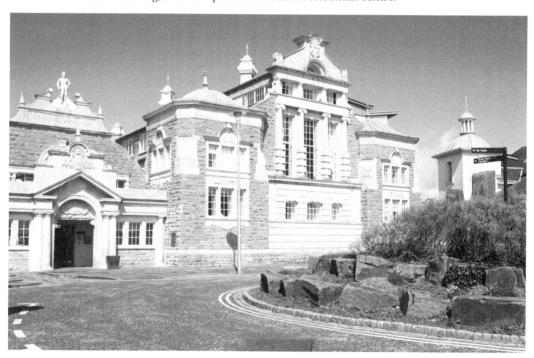

Knightstone Reflections
A romantic image of the Knightstone peninsula taken in about 1970. The redevelopment on the former island has created a new skyline for the twenty-first century, seen in the modern photograph from the renewed causeway.

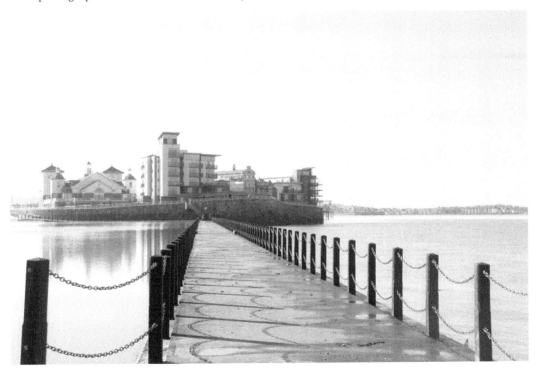

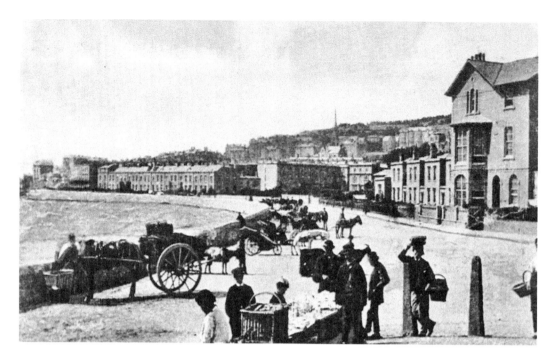

Glentworth – North from Knightstone
In this very early photograph which dates to about 1875, the atmosphere is as much that of a fishing village as a seaside resort. Before either of the piers had been constructed, this is where the local fishing boats would have landed. If the date is correct then this is a view of the old esplanade of 1828/29. The spire of Holy Trinity church, built in 1861, is an obvious landmark on the hillside.

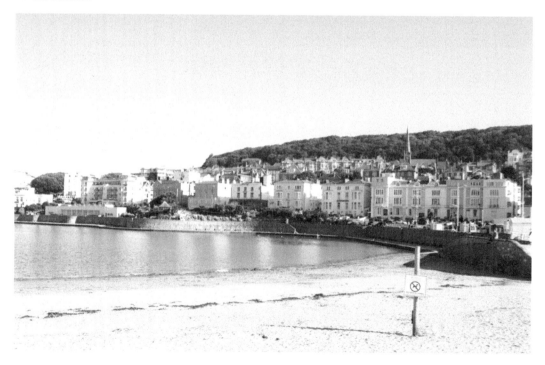

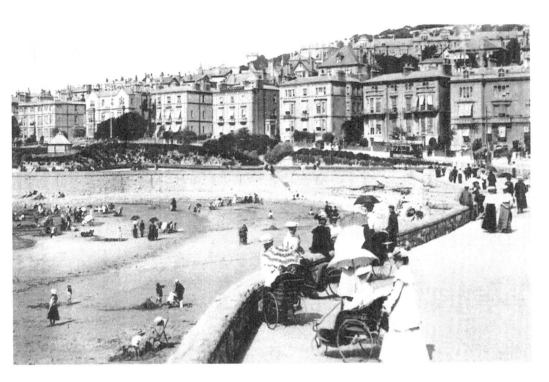

Glentworth – North from Knightstone

Some years later, and a decade or more after the building of the later seafront walls of 1887, the same area of the promenade has now adopted the character of a seaside resort. Although there has been much demolition and reconstruction of the houses and hotels overlooking the bay, the scene today is remarkably similar.

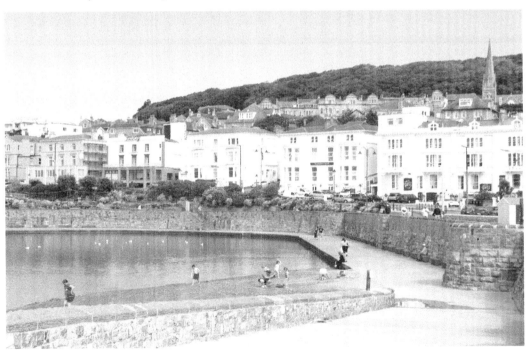

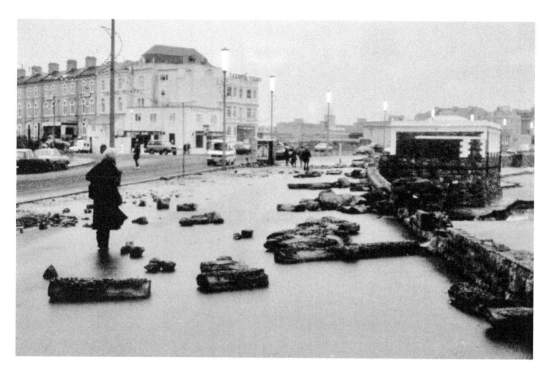

1981 Floods

Most seaside resorts look less than at their best in the winter months, but Weston looked very bleak after the storm of December 1981. Many of the large capping stones which had resisted the high tides and winds for over a century lay strewn across the promenade. The large rocks that are there today add strength to the new inner flood wall.

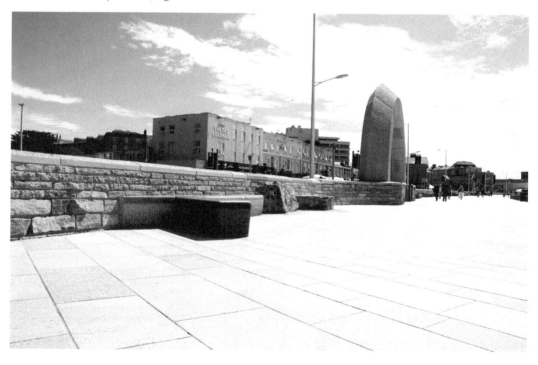

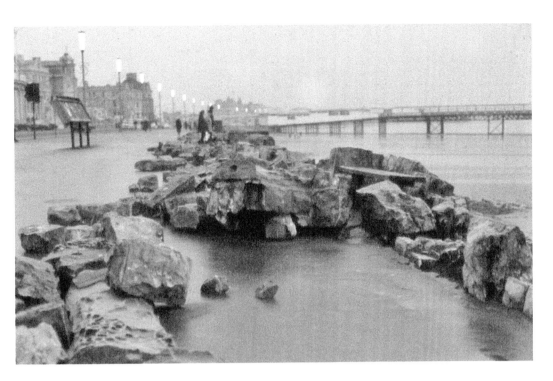

1981 Floods

The sea wall is almost unrecognisable, and the information board displaying posters of Weston's attractions has been twisted by the gale-force winds. The new arch was designed by sculptor John Maine RA. The coping stones were incorporated in the rebuilding of the sea wall in 2009/10, having been reinforced internally with resin and steel.

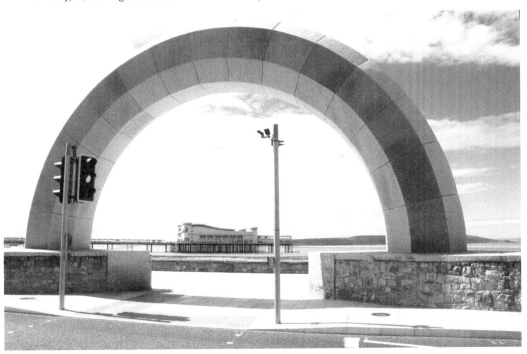

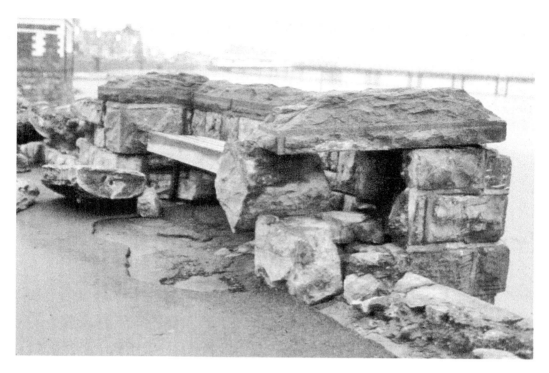

1981 Floods

The simplicity and style of the 1887 wall is exemplified in this promenade seat which is both functional and full of character. One of the many successes of the most recent flood defence project has been in retaining the Victorian character of the promenade whilst employing twenty-first century construction techniques.

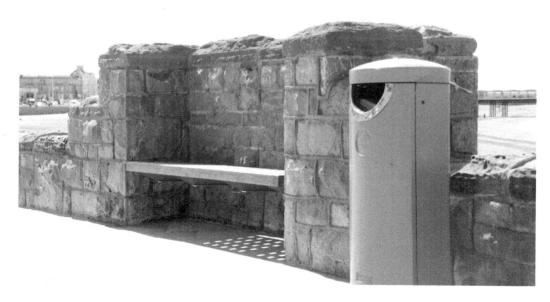

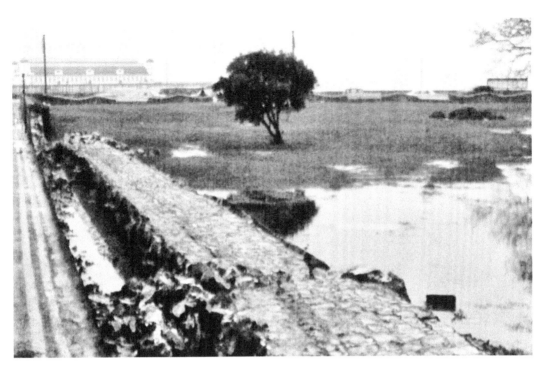

1981 Floods

One of the most popular children's attractions of the present time is this adventure playground on land set back some distance from the beach. Yet the photograph from 1981 shows how far inland the flood damage reached.

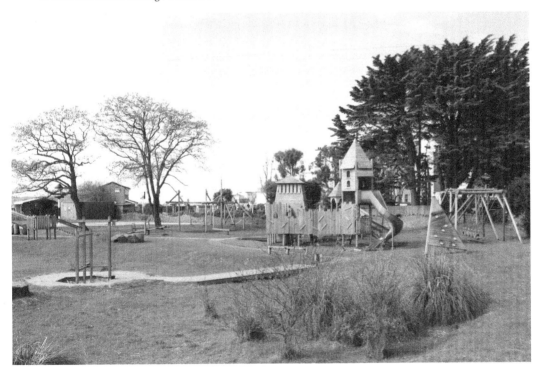

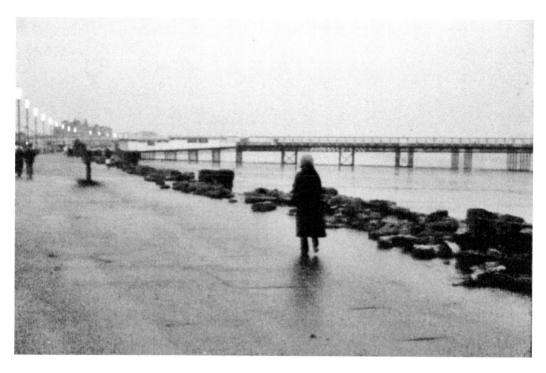

1981 Floods
Both sections of the flood defences – the original sea wall and the new inner wall – can be seen in this view of the promenade looking south from Knightstone towards the Grand Pier. The diagonally laid block paving helps to emphasise the wide space of the promenade.

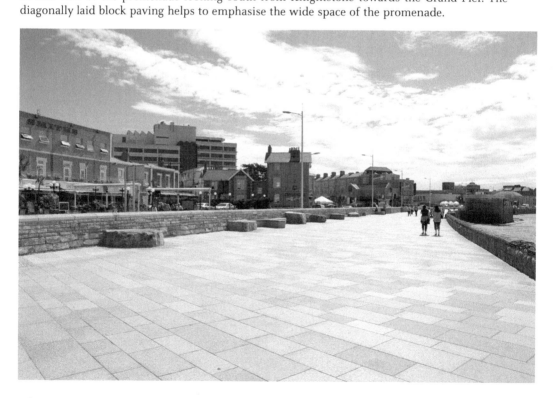

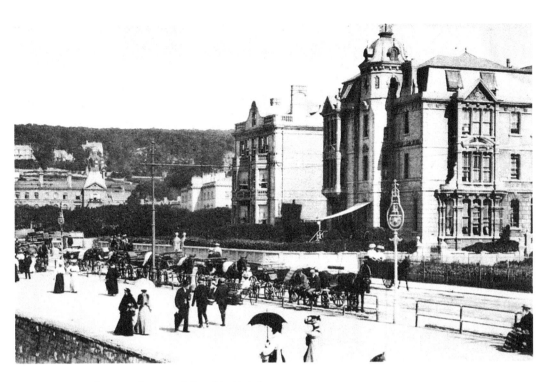

Promenade – Donkeys and Seaside Hotels

A typical view of a traditional English seaside resort. Donkeys have been a part of Weston's history since the beginning. They were used by the local fishermen to transport their catches and nets. Above stand two of Weston's well-known small hotels, the York and the Sandringham.

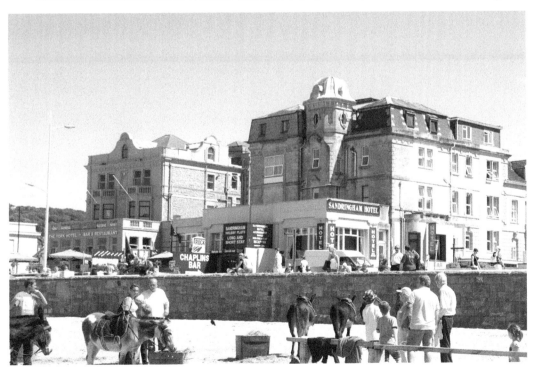

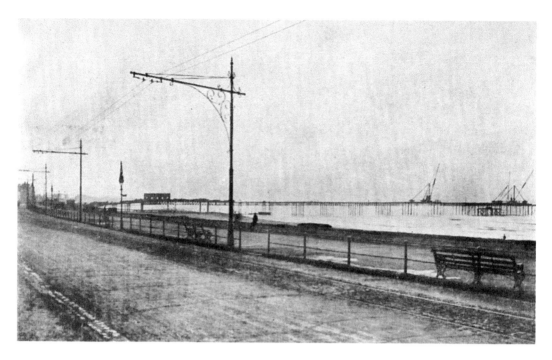

Grand Pier Construction
A rather bleak view of construction work on the Grand Pier from the promenade looking south. The first section of the pier opened in June 1904. A further section, which was no less than a full half mile in length, opened in 1906. However, strong currents in the channel caused silting and only three vessels ever berthed here. The extension was taken down in 1916. The modern view of the Grand Pier is from Dr Fox's Tearoom on Knightstone.

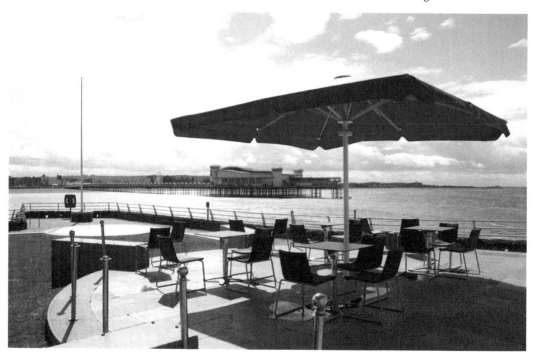

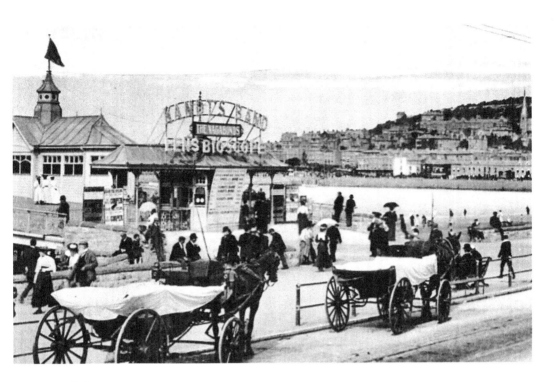

Grand Pier Entrance

The cluster of buildings forming the entrance to the Grand Pier has undergone many facelifts over the past one hundred years, but this photograph is of the original layout. Kandy's Band, the Vagabonds and a Bioscope are the attractions advertised above the entrance. Two clocks on the side of the booth near the turnstiles indicate the high and low tide times.

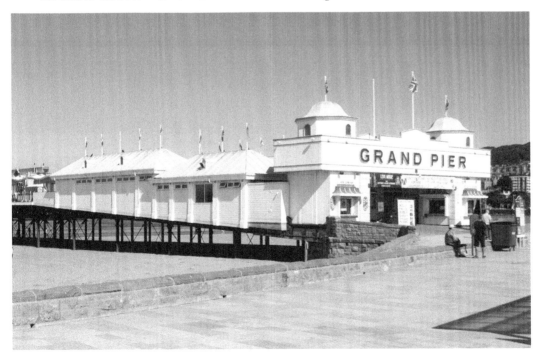

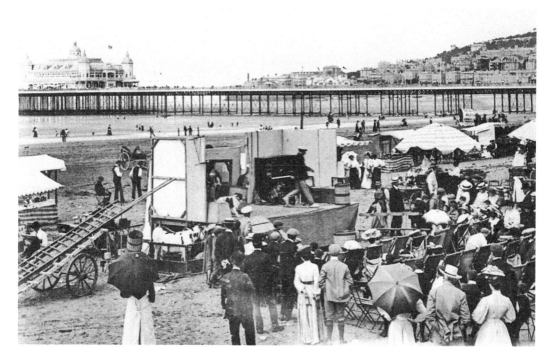

Grand Pier and Beach

In the Victorian and Edwardian eras, the beach offered a multitude of entertainments including music and dance troupes and dramatic tableaux performed on mobile stages. There were rides, organised games, markets and evangelical services. When the tide came in, many similar activities were to be found above, along the pier.

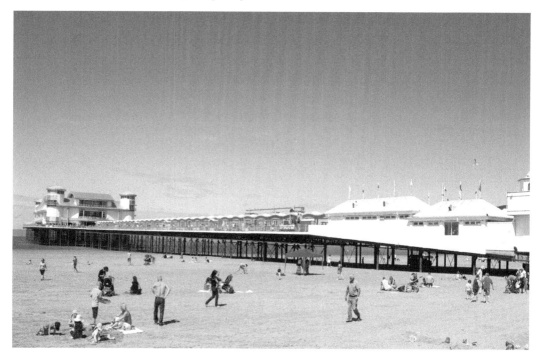

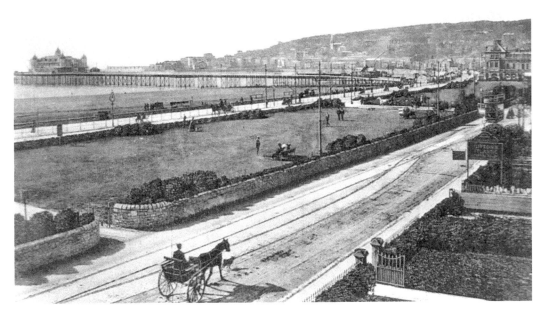

Beach Lawns from the Grand Atlantic Hotel

Two earlier modes of public transport are to be seen in this early photograph taken from a top window of the Grand Atlantic Hotel. Travelling north is a horse and cart steering clear of the tramlines at the passing loop. A tram is approaching from the north. Huntley's famous Beach Hotel and Restaurant can be seen on the far right.

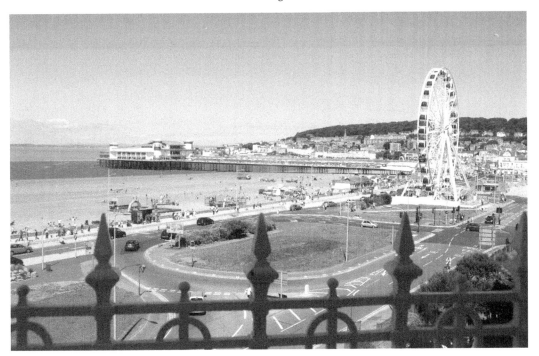

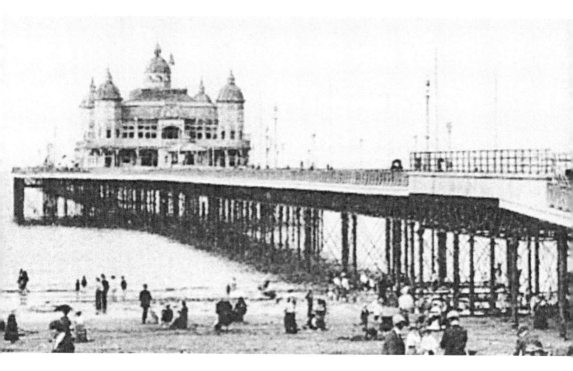

Grand Pier Pavilion
The Grand Pier was opened in 1904, but was badly damaged by fire in 1930. It took three years to rebuild the structure. In July 2008, fire once again destroyed the pavilion. It was rebuilt and reopened two years later.

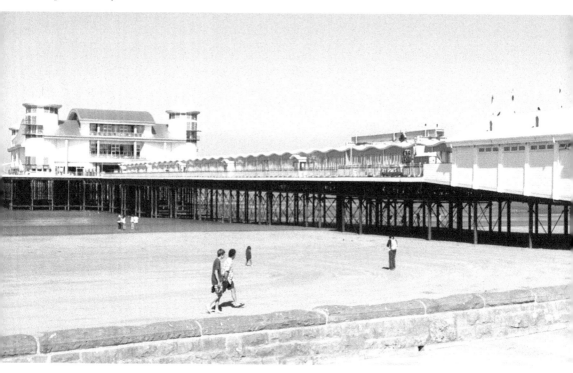

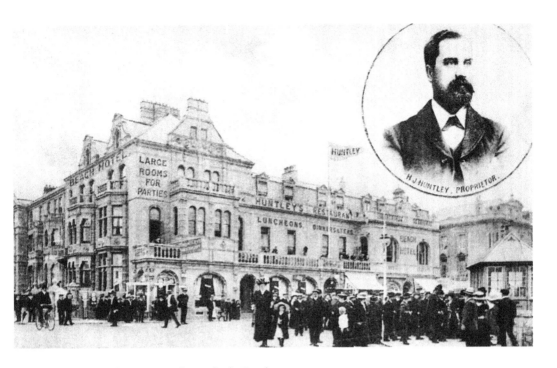

Princess Royal Square and Huntley's Hotel

The section of the beach lawns opposite the Grand Pier became known as Pier Square, and at night, the twenty-first-century lighting speaks that name in the form of coloured Morse code. On Monday 25 July 2011, it became Princess Royal Square when Her Royal Highness, The Princess Royal unveiled a plaque to that effect. Dominating the square at the end of Regent Street is the proud edifice of H. J. Huntley's Beach Hotel and Restaurant, part of which was formerly Whereat's Reading Rooms, built in 1826.

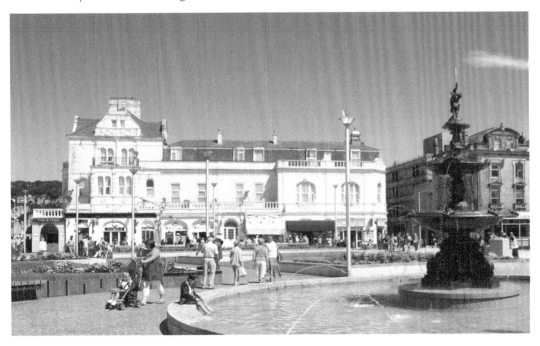

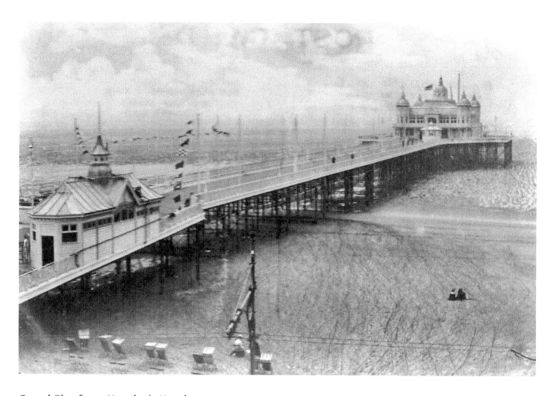

Grand Pier from Huntley's Hotel
A view of the Grand Pier from an apartment window in Huntley's Hotel, well above the poles
carrying the electric cables for the trams.

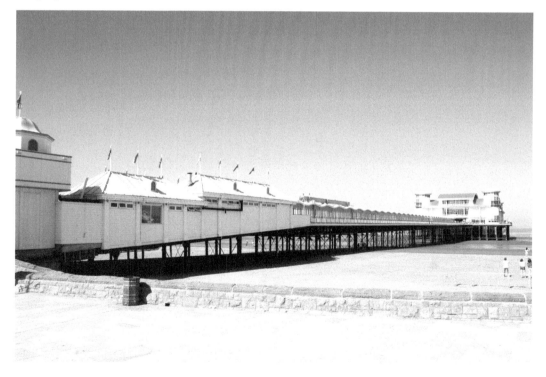

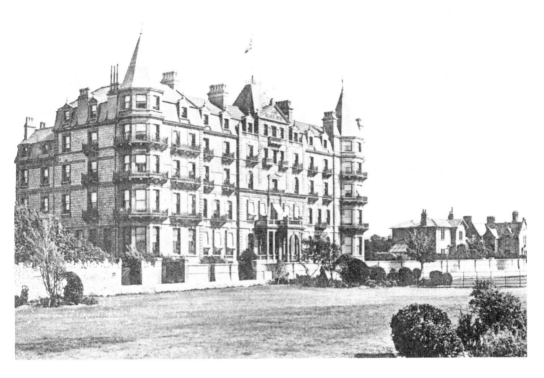

The Grand Atlantic Hotel
The ornate façade of the Grand Atlantic Hotel, built in 1859, still dominates the Beach Road, but now competes in scale with newer buildings and seaside features.

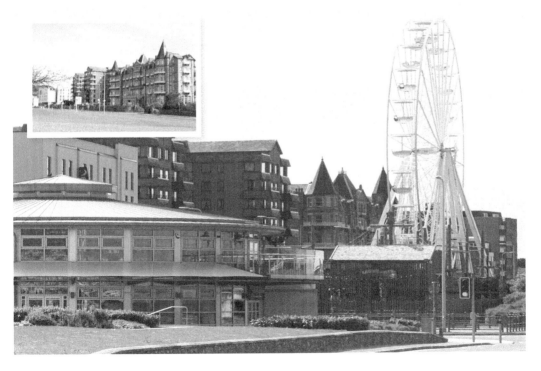

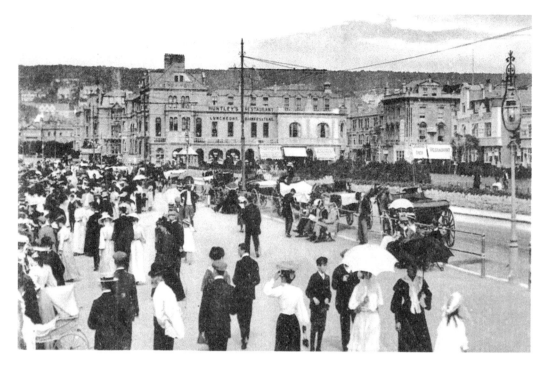

Princess Royal Square

The junction of Regent Street and the Beach Road is very much the bustling centre of Weston's seaside landscape in the middle of the sweeping bay between Uphill and Worlebury. The recent imaginative refurbishment of this green square between Beach Road and Royal Parade has enhanced the area considerably.

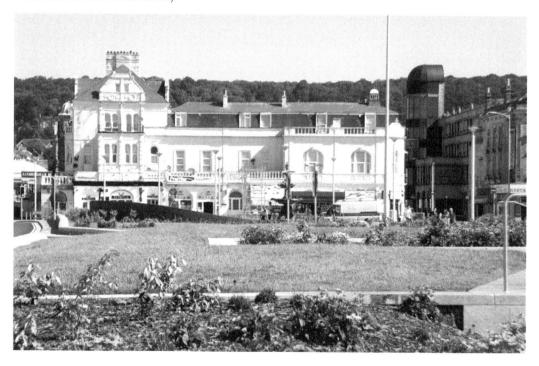

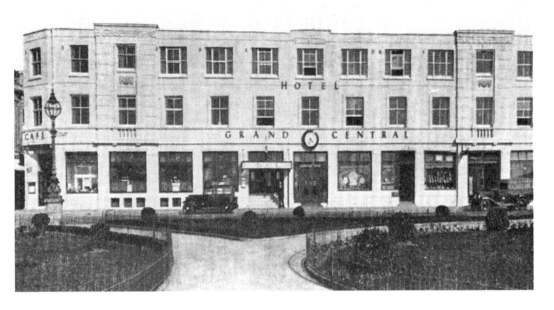

The Grand Central Hotel

The author remembers delicious ice-cream sundaes made and served here by Mr Forte in his ice-cream parlour, now the VII bar. The lawns were landscaped in 1910 and in 1913 Thomas Macfarlane donated the Coalbrookdale Fountain, more popularly known as the 'Boy and Serpent'. This was restored in 2011 when it was switched on by Thomas's great-granddaughter, Mary Macfarlane.

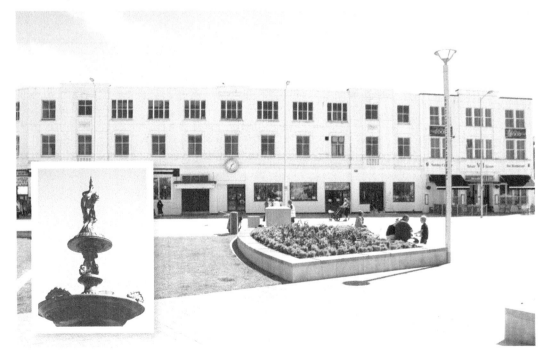

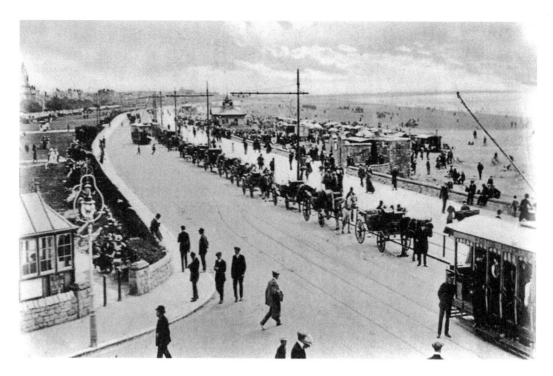

Princess Royal Square from Huntley's Hotel
Apparently a sunny day when the earlier photograph was taken because of the presence of a 'toastrack' tram (*right*). If it rained, these open trams returned to the depot to be replaced by double-deckers. During the First World War, Weston had the first female tram drivers in the country.

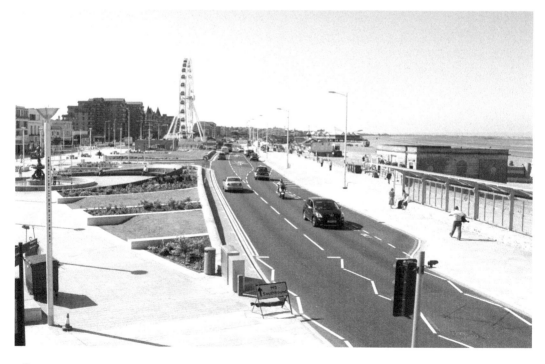

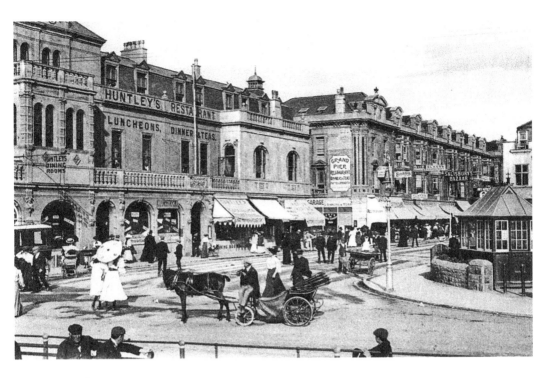

Regent Street

The rooflines and frontages have changed but the business enterprises remain, geared to welcome the visitors as well as the town residents. Regent Street once marked the southern limits of the town but became its axis, connecting the main Locking Road approach to Weston, the nearby railway stations and the High Street.

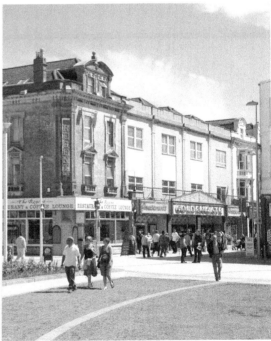

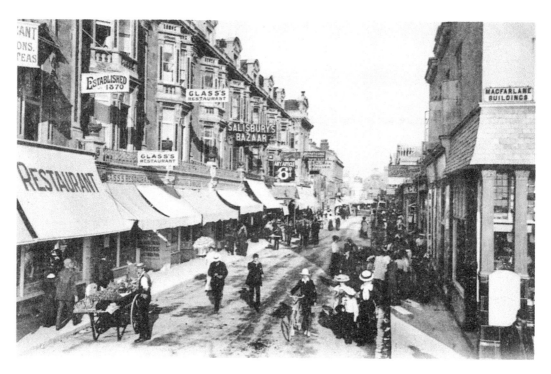

Regent Street

Regent Street connects Weston's shopping centre with its beach. In the distance is the 'big lamp' junction with High Street. Restaurants, bazaars and 'Any article 6d' have become fast-food outlets, souvenir stores and pound shops.

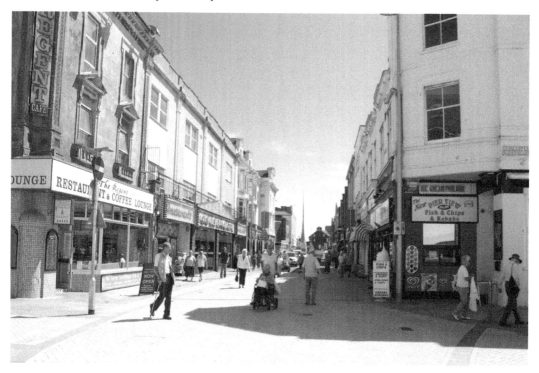

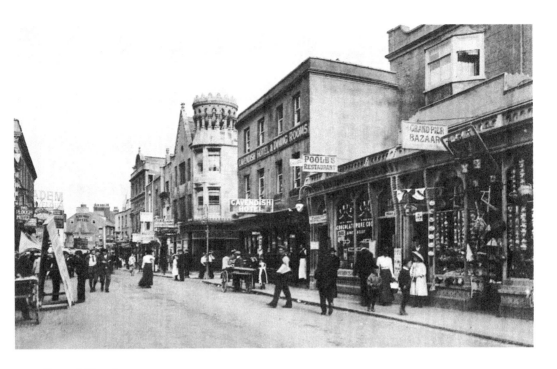

Regent Street

Many of the Victorian buildings have been demolished or radically rebuilt. The tower at the junction with St James Street (*right*) has gone, but the rest of that building's roofline remains identifiable. In earlier times, the Wesleyan church was on this corner. In the distance can be seen the controversial needle-like structure of the Silica, a 26-metre-high work of art commissioned by North Somerset Council at a cost of over £350,000 and completed in 2006.

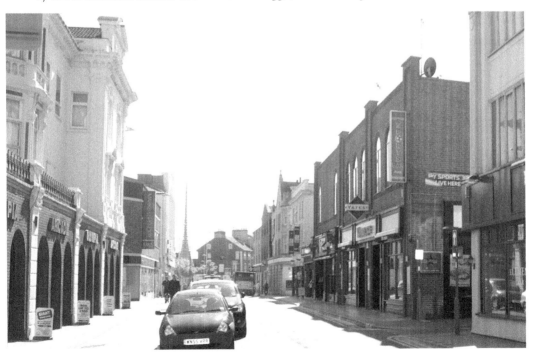

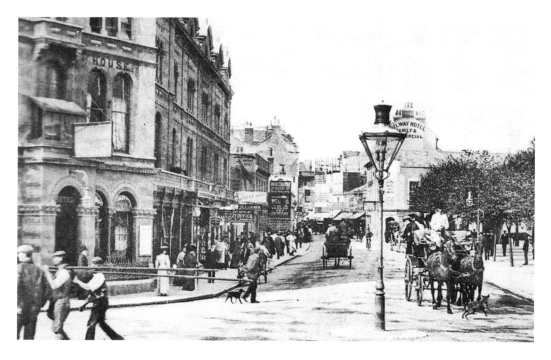

Regent Street from the Odeon Corner

A view of Regent Street looking towards the beach from Locking Road and the junction (*left*) with Walliscote Road. To the right is the 'plantation', the site of the town's first railway station. In the distance, behind the trees, is the original Railway Hotel. For many years this area was also known as Old Station Square and more recently as Alexandra Parade. On the corner of Walliscote Road are the Magdala Buildings designed by Hans Price.

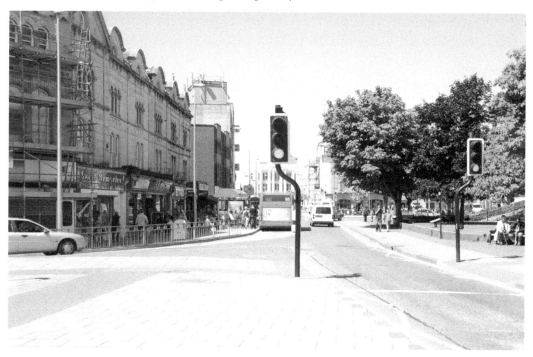

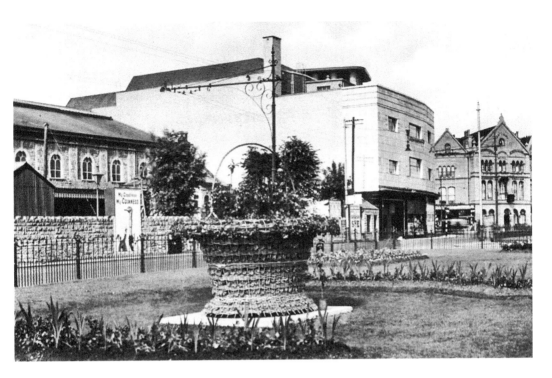

The Odeon and the Plantation

This green space by the side of Weston's Odeon Cinema and Locking Road was the site of the town's first railway station opened in 1841. The building to the left of the Odeon, now the site of a supermarket, was part of the second of Weston's railway termini. The first site was later gifted to the town and planted with trees, hence 'the plantation'.

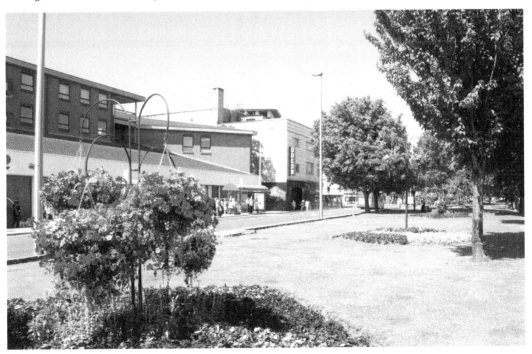

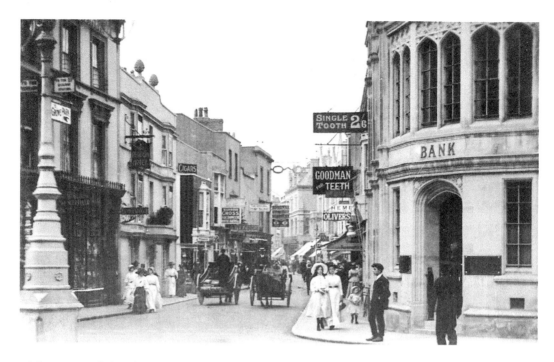

High Street and the Big Lamp Corner

The 'Big Lamp' corner is known to all Westonians as the junction of High Street and Regent Street, where for many years a policeman on point duty controlled the traffic. In fact, this was the site of the village green and where the HSBC bank now stands was known as 'Gossip Corner'. One of the town's oldest streets, High Street has served as the major shopping area for more than a century.

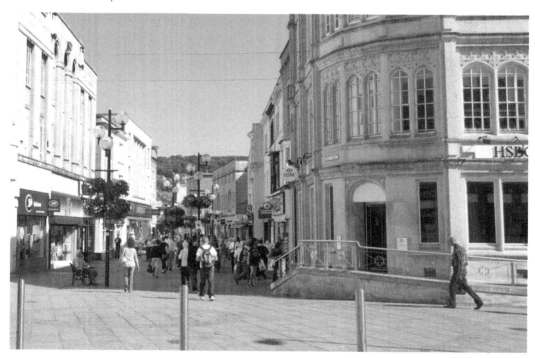

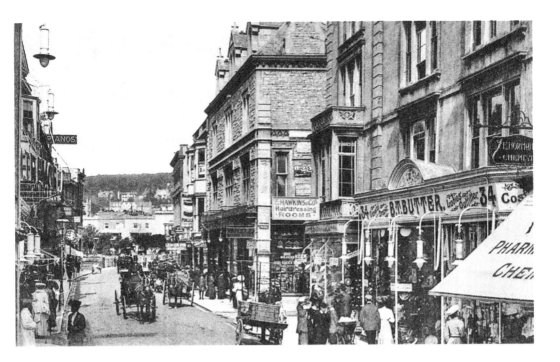

High Street – Woolworths

High Street successfully retained the big names of the retail industry. Dominant was Woolworths, occupying the former Non conformist church of 1858 in the heart of the street, and nearby were both famous local and national brands including Butters, Walker & Ling, Lances, Carwardine, Boots, Littlewoods, Marks & Spencer, Timothy Whites, Currys and Dixons. The fittest have survived.

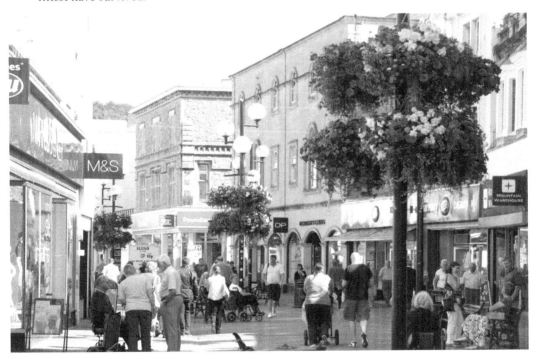

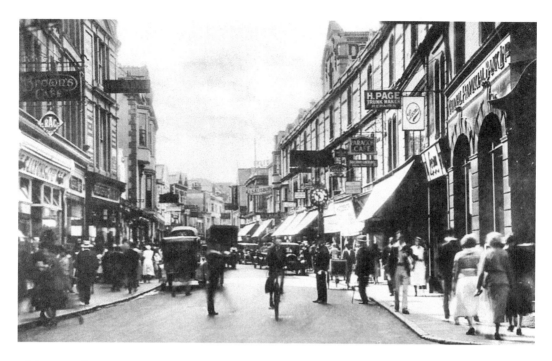

High Street from Lances Corner

The northern end of High Street is still known as 'Lances Corner', more than seventy years since Lance & Lance's department store was destroyed by enemy bombing in 1942. By the 1960s, a Burton's supermarket occupied the site, later to become Fine Fare. More recently, the Argos chain moved into this prime location. Possibly the most familiar image in the earlier photograph is the clock outside John Rossiter's Jewellery shop. The business was founded in 1832.

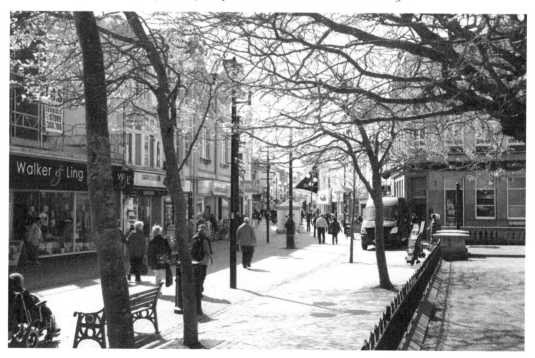

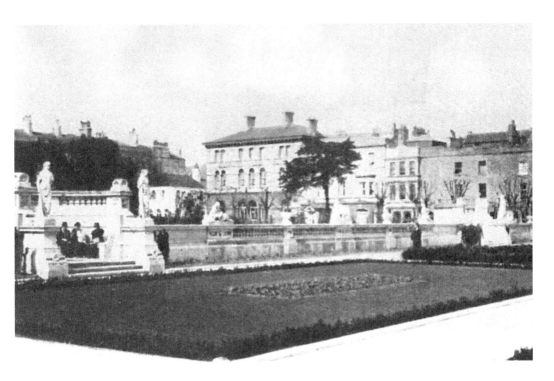

Town Square

Many visitors expect to find a Town Square near to the Town Hall, but in Weston it is situated at the northern end of High Street. It is a significant location in the oldest part of the town on land gifted by one of its most famous and infamous mayors, businessmen and local landowner, Henry Butt.

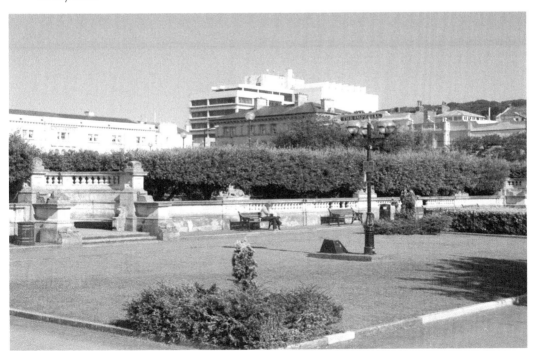

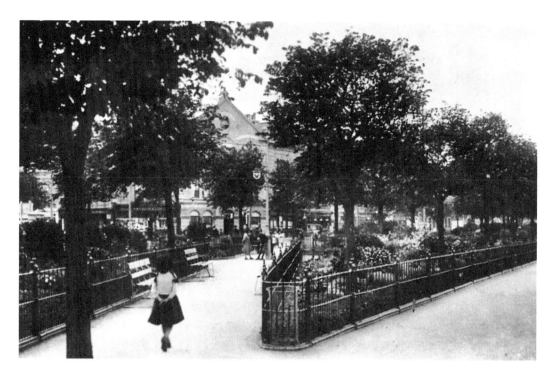

Town Square

Town Square is part of a much larger area of land which encompassed the Winter Gardens and connected the High Street with the seafront. It is now bordered on its southern boundary by the Sovereign Centre.

The Post Office
Before the arrival of the Bristol & Exeter Railway in 1841, the postal service in Weston depended on horse-drawn carriages. The General Post Office, built in 1899 on the site of the former Veranda House by the side of the present Town Square, was a building of dignity. It was demolished in January 1990, shortly after this photograph was taken.

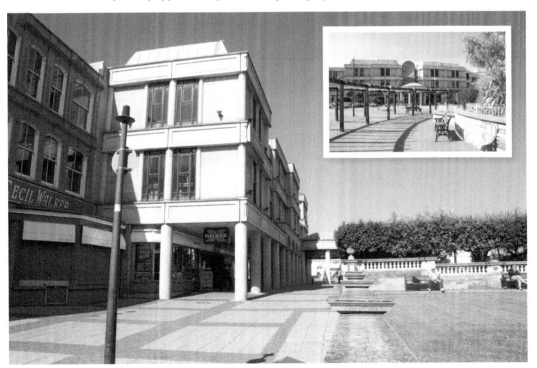

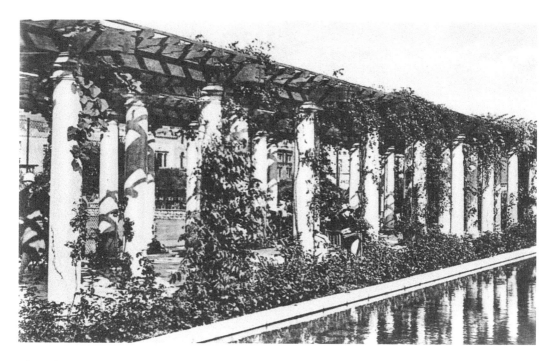

The Winter Gardens Lily Pond
The gardens, including the lily pond behind the Winter Gardens pavilion, are still an enchanting oasis in the heart of the town. They were laid out on the former Hotel Field which was given to the town by one of its larger-than-life residents, millionaire businessman and sometime mayor, Henry Butt, in settlement of a long-running dispute over damage caused to roads by vehicles involved in his quarrying operations.

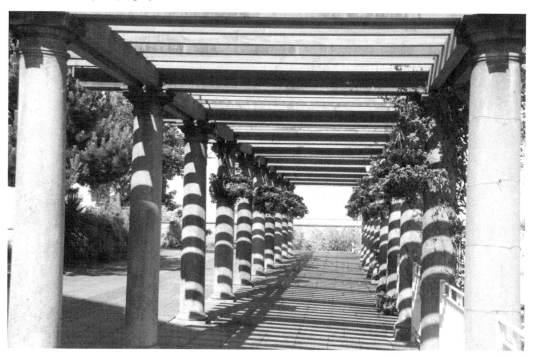

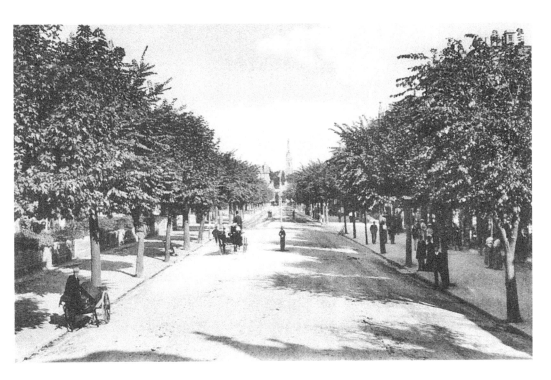

Waterloo Street

Waterloo Street was constructed in 1860 and leads into the wider and more refined Boulevard. Weston's finest architect, Hans Price, had his offices here at No. 28. He also designed the Weston Mercury building in 1855, which is still used by the same journal today.

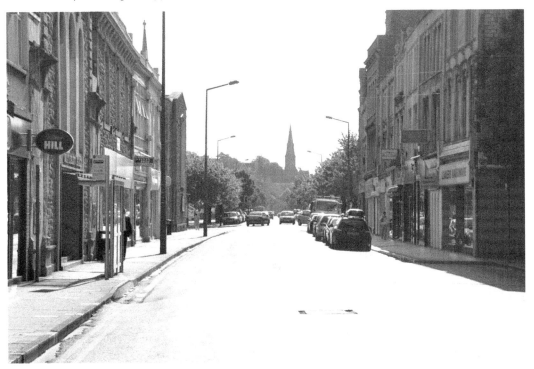

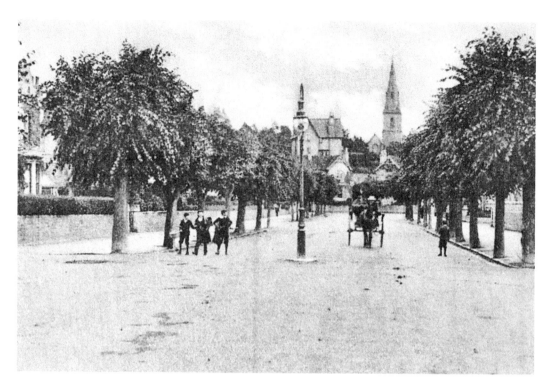

The Boulevard

The Boulevard was also laid out in 1860. Waterloo House, built in 1815, the year of the battle of Waterloo, was partly demolished to make way for this wide tree-lined development aligned to the spire of the relatively new Christ Church at Montpelier. Another of Hans Price's fine buildings is the former public library, built to mark Queen Victoria's jubilee and opened in 1900.

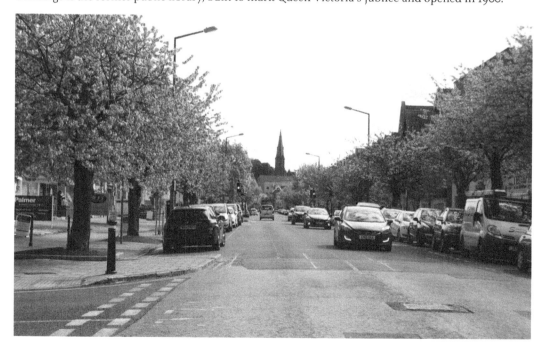

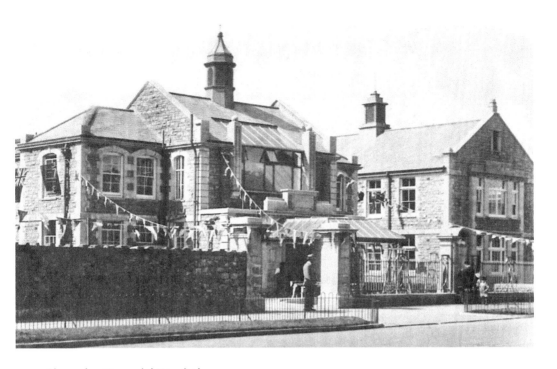

Alexandra Memorial Hospital

The Duke and Duchess of York, who were later to become King George VI and Queen Elizabeth, opened Weston's General Hospital in 1927. This photograph is dated 1928, but may well be a record of the opening day. The building incorporated earlier premises in nearby Alfred Street. It served Westonians well for sixty years until the new hospital was constructed at Uphill. This fine building was saved from demolition and is now a modern apartment block renamed Henry Butt House. Butt was instrumental in raising the money needed to build the original hospital.

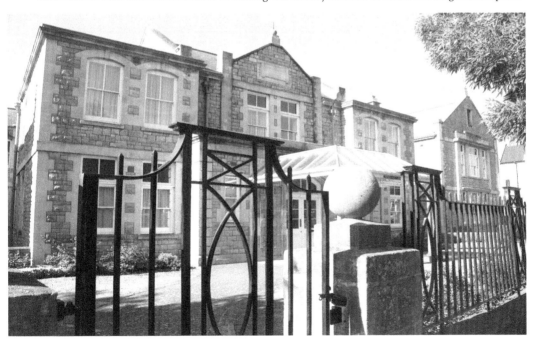

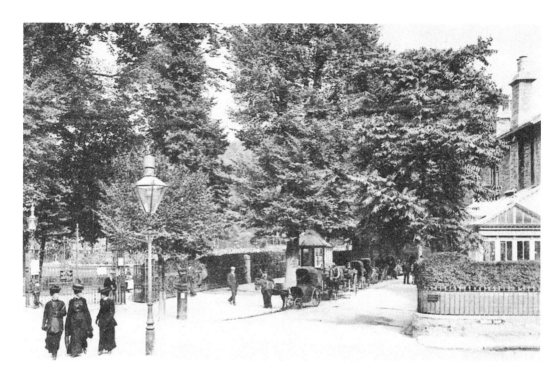

Grove Park Entrance

Grove Park was opened to the public on 20 June 1891. The land had been owned by the Pigott family since 1696 when they acquired Grove House. John Hugh Smyth-Pigott (1793–1853) planted out Weston Woods and it was his intention that his 'garden' should merge with the trees on the hill above.

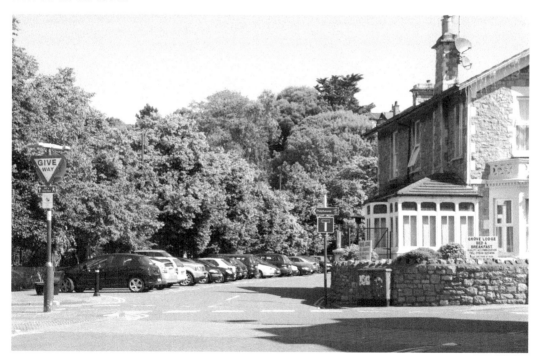

Grove Park – The Rockery

The Enclosure award allowed John Pigott to create a small park with lawns, shrubbery and a sweeping drive. Although he constructed terraces around the house, the rockery dates to the Corporation's work in 1890. The ponds are built over a small quarry.

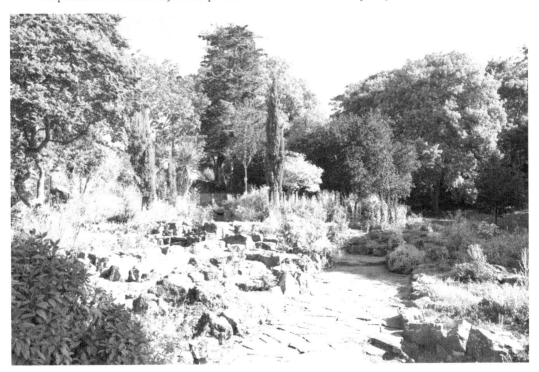

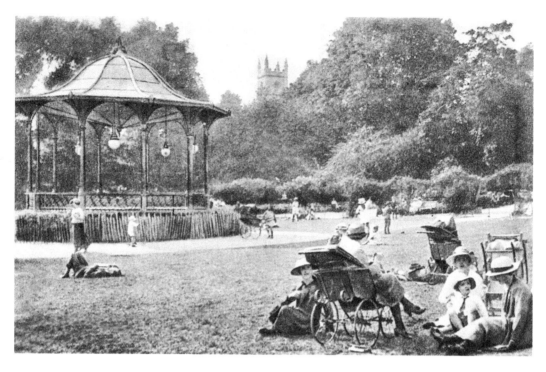

Grove Park Bandstand
The bandstand was one of the works undertaken by the Corporation in 1890. The ironwork was made by Hill Brothers at their Sun Foundry in Alloa, Scotland, and cost £135. It is Grade II listed and was fully restored in 2014.

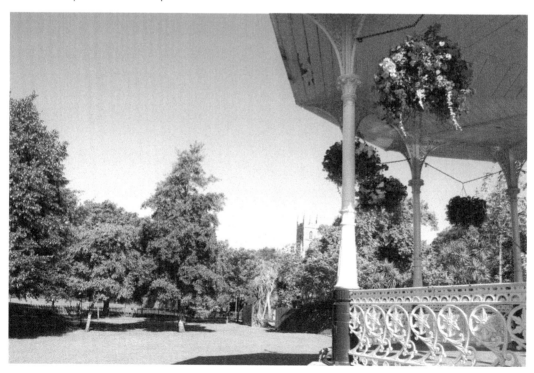

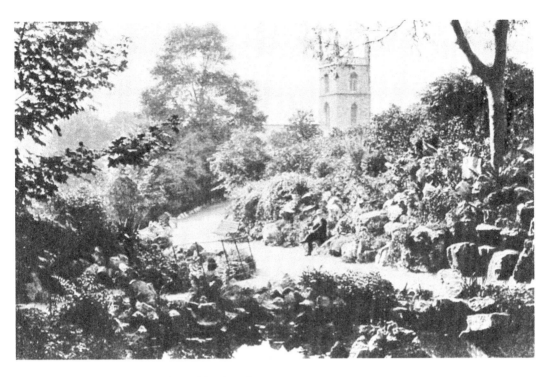

Grove Park and St John's Parish Church

The parish church of St John provides a perfect backdrop to Grove Park. However, this scene is not of any great antiquity. The church was rebuilt in 1824 at about the same time that the bare hillside above was being planted with trees.

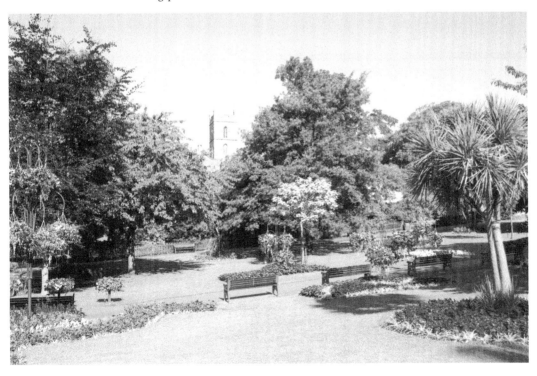

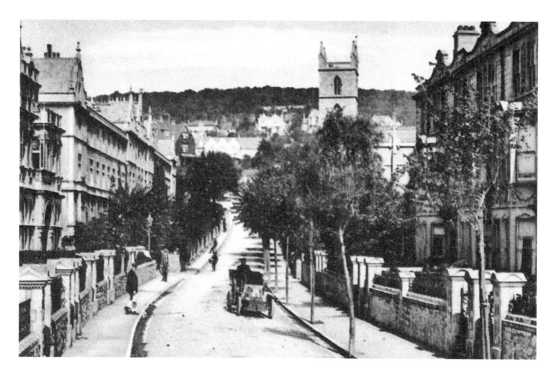

St John's Parish Church
Weston's parish church viewed from Lower Church Road. Little is known of its early history, although the grant of the advowson is recorded in the Diocesan records in 1221. As late as 1822, the officiating minster of the parish was living in Locking.

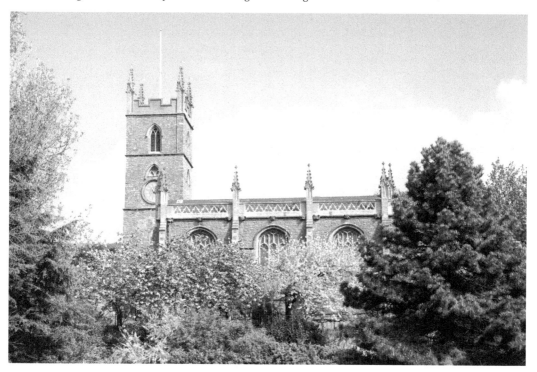

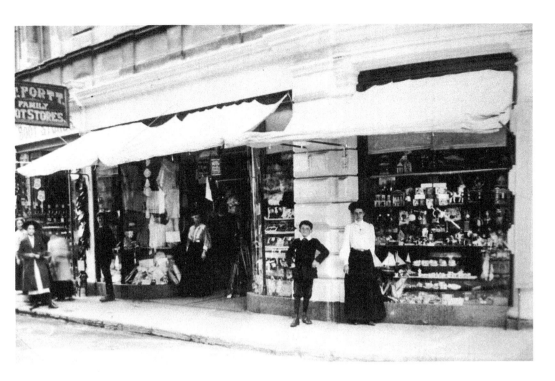

The Lamp Shop, West Street
The tranquillity of Grove Park is but a few minutes away from the bustle of Weston's shopping areas. The Lamp Shop was on the corner of High Street and West Street. Opposite, on land now occupied in part by the Playhouse, was the town's market. This photograph dates to about 1910.

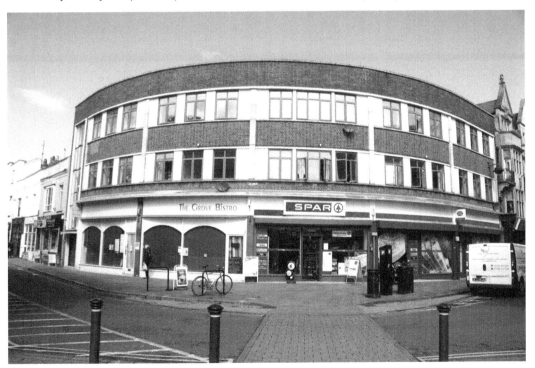

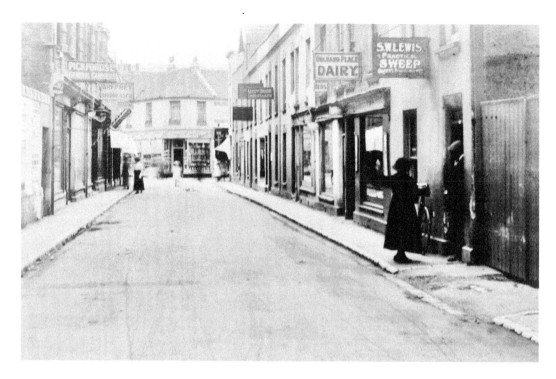

Orchard Place

A sombre image of Orchard Place looking towards the junction with Meadow Street and Palmer Street. The shops and businesses include Parffrey, hairdresser; Pickfords, general carriers; the Orchard Place Dairy; S. Lewis, practical sweep; and the union undertaker. This photograph was taken at 7.30 p.m. on 12 June 1918, five months before the end of the First World War.

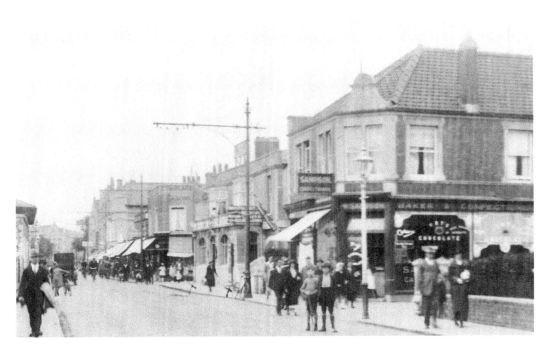

Locking Road

Locking Road became the major route for day-trippers from the 1960s when more families were able to own a motor car. Their route passed the site of three of the town's earlier railway stations. The Tesco supermarket now occupies the site of the 1866 and 1914 stations. Alexandra Gardens (the 'plantation') on the opposite side of the road is where Weston's first railway station was built in 1841.

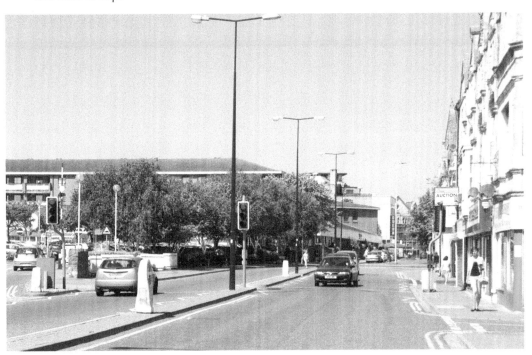

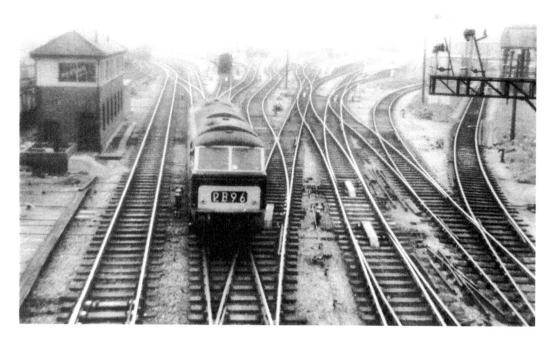

The Railway Station from Drove Road Bridge

This photograph taken from the Drove Road Bridge shows the tracks curving right towards the Locking Road excursion platforms which were built in 1914. The track behind the signal box led to the gasworks and followed the route of the first railway line into Weston laid down in 1841 across the Drove Road.

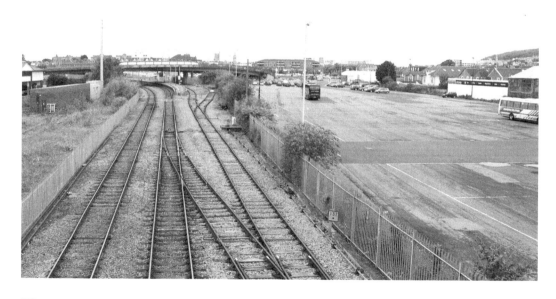

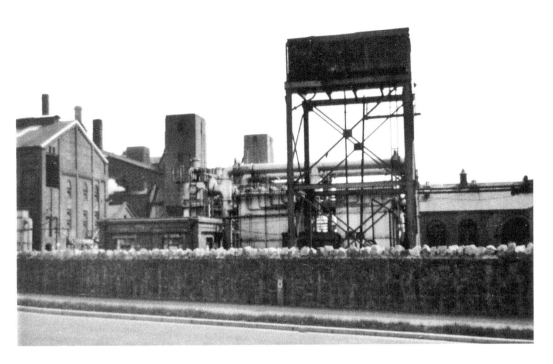

The Gasworks

Gas came to the town in the same year as the railways. The first gasworks were close to the Town Hall. New works were built on the Drove Road between 1852 and 1856 which closed in 1972. Coal was delivered to the site by rail, involving a level crossing at the junction of Winterstoke Road. The last remaining gasometers have now been demolished and the site, in 2015, was awaiting redevelopment.

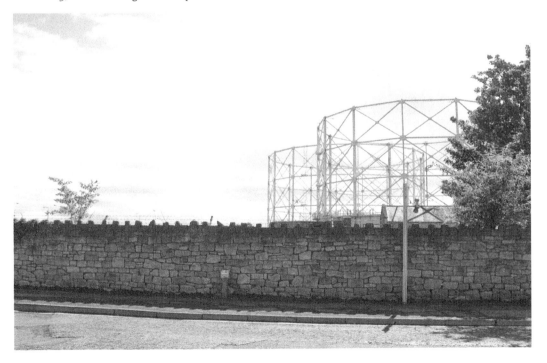

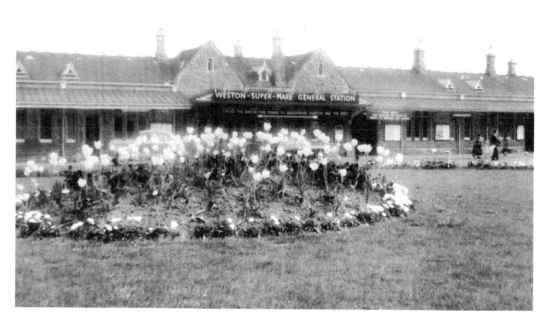

The Railway Station

The through station on the loop line was opened on 1 March 1884. The curved frontage and the sweeping station approach provided an attractive environment for intending passengers and room for a fleet of station taxis. Today, the hard landscaping has diminished its charm.

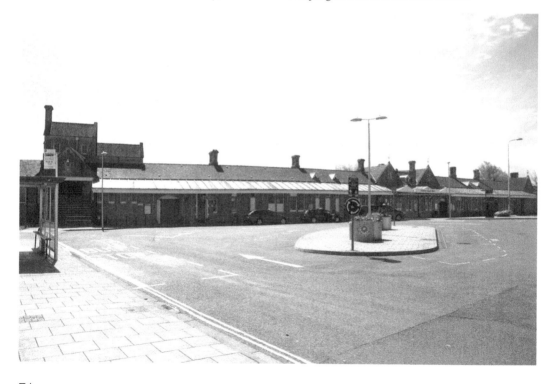

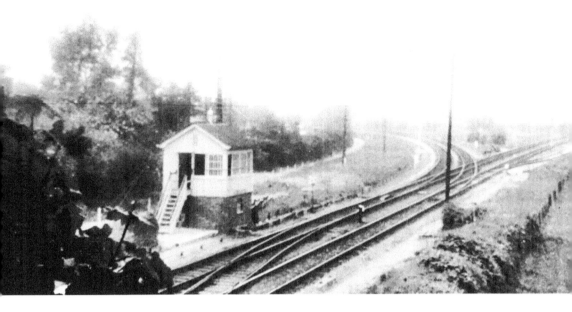

Uphill Railway Junction

The loop line through the town was built in 1884 following some years of uncertainty regarding the final route. It remained as a double-track operation until 1972, when the manned signal boxes at Worle and Uphill junctions were demolished.

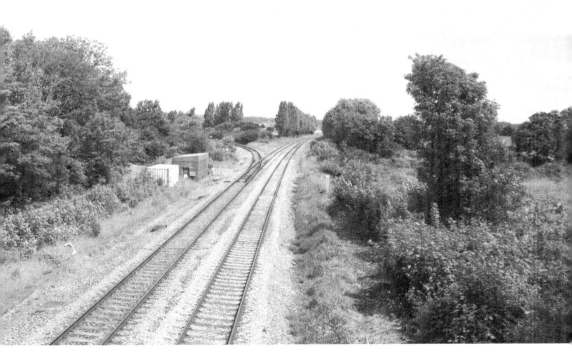

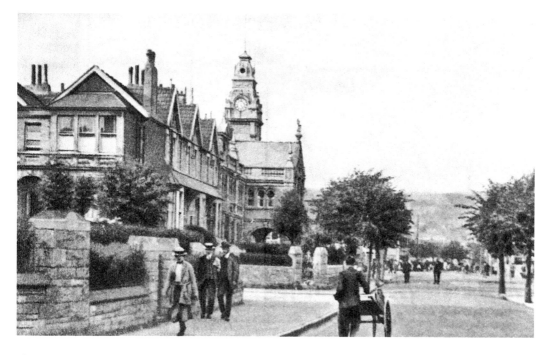

The Town Hall

The Town Hall is another example of the work of Weston's own architect of great merit, Hans Fowler Price, who created so many buildings of dignity and eloquence. The original hall was begun in 1858, and presented to the town in the following year by Archdeacon Law, the former Rector of Weston, following a dispute over the alleged vested interest in the land of a town commissioner, Henry Davies.

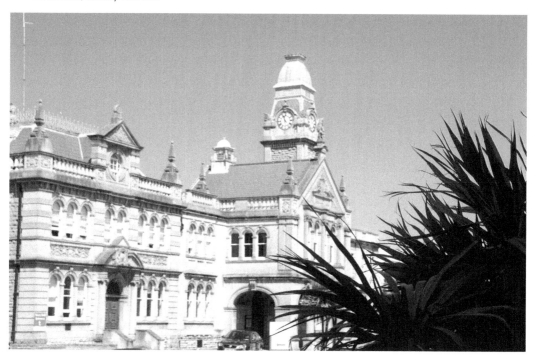

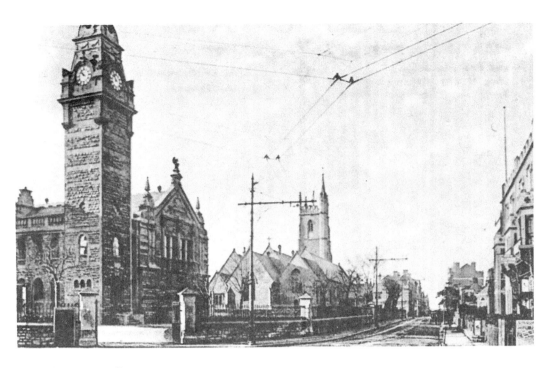

The Town Hall

Over the years, the Town Hall has been altered to match the changes in local governance. Hans Price redesigned the campanile clock tower and added the south wing and entrance in 1897, and a further extension was completed in 1927. In June 2011, North Somerset Council undertook major refurbishment which included accommodation for the town library. Adjacent, on Oxford Street, stands Emmanuel church.

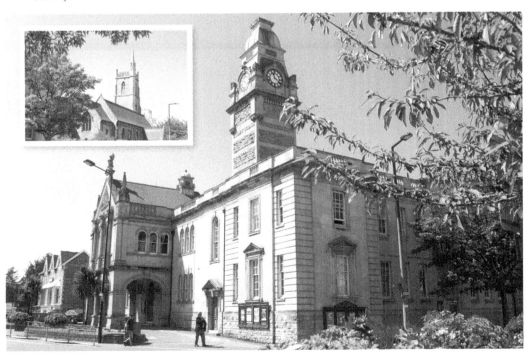

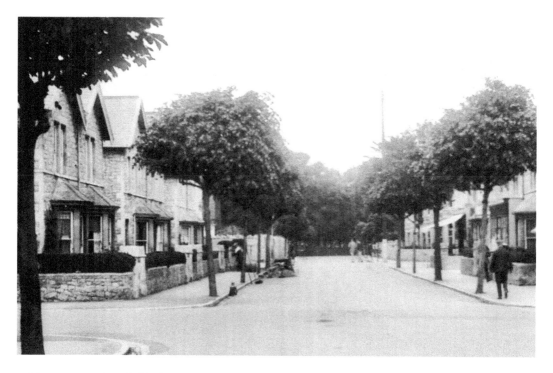

Whitecross Road and Ellenborough Park

The land between the town centre and Uphill was the old Whitecross Estate and was acquired by local entrepreneurs W. Henry Davies and Joseph Whereat in 1846. They built the impressive Ellenborough Crescent and Park in 1855. It was named after the Rector of Weston, Archdeacon Law's brother, Lord Ellenborough, a former Governor of India.

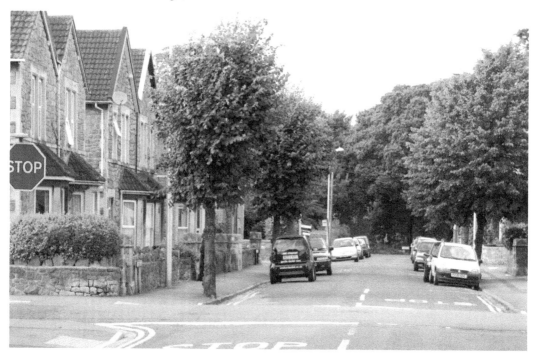

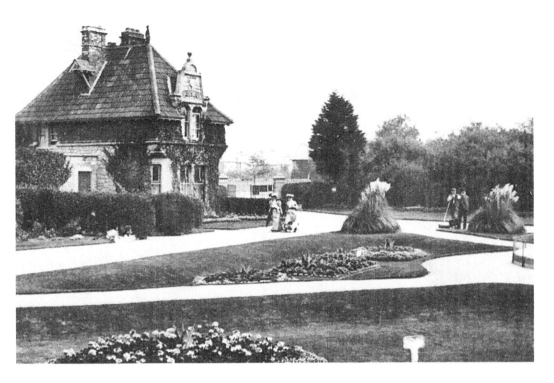

Clarence Park, The Lodge

Clarence Park, divided into an east and a west park by the Walliscote Road, lies in the heart of the old Whitecross Estate and was given to the town by Rebecca Davies, widow of Henry, in 1883. Mrs Davies also set aside the land next to the parks in order that a church (St Paul's) could be built to serve those who lived in the many terraces of houses built by her husband.

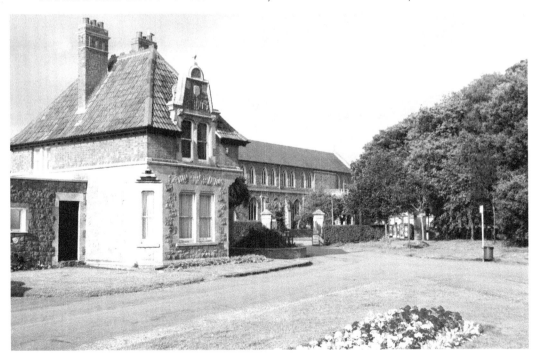

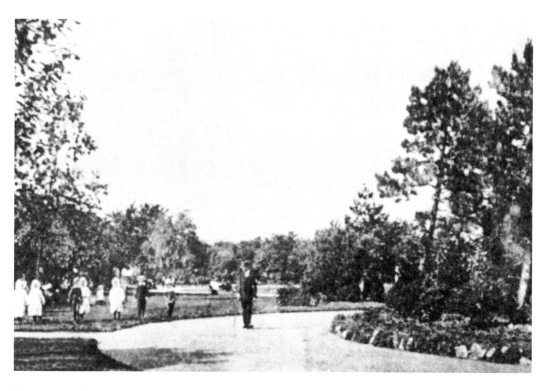

Clarence Park

A very early photograph of schoolchildren playing an organised game in Clarence Park. They attract the attention of a local man who is evidently taking an afternoon stroll.

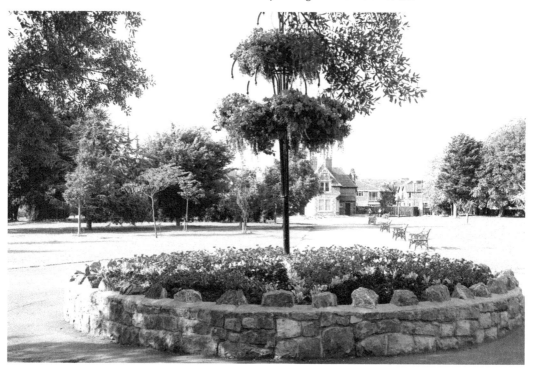

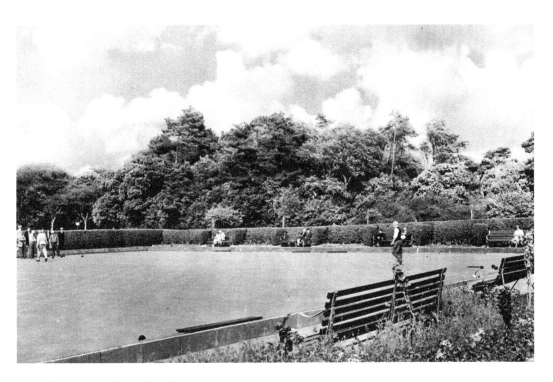

Clarence Park Bowling Greens

The first bowling green in Clarence Park was laid out in 1907 and the Clarence Bowling Club was established in the same year. Ladies were admitted in 1926 and by 1929, two further greens had been added in response to the popularity of the game.

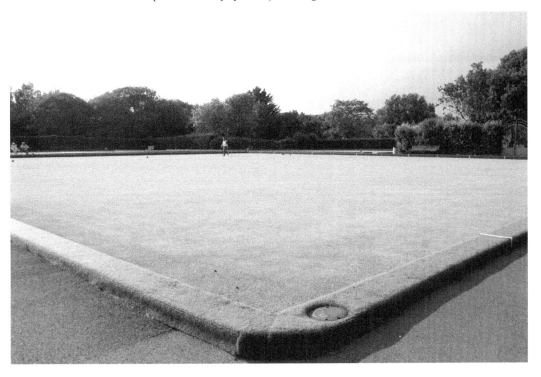

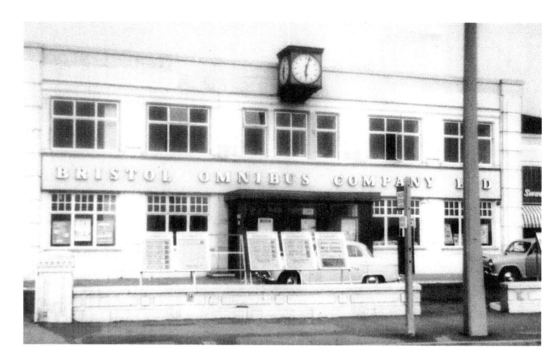

The Bus Station

The seafront bus station was constructed in 1928 on the site of the former Belvedere Mansion, and enabled passengers from Bristol to step straight out onto the Beach Road. The Bristol Omnibus Company began with tramway services in Bristol in 1875. Its smart green buses were familiar to all in the latter half of the twentieth century with cream-coloured, open-top double-deckers on the seafront route. The new apartment block overpowers with its dark presence.

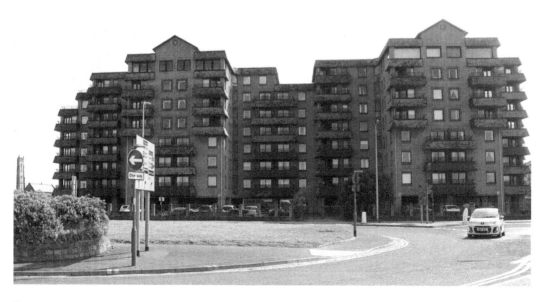

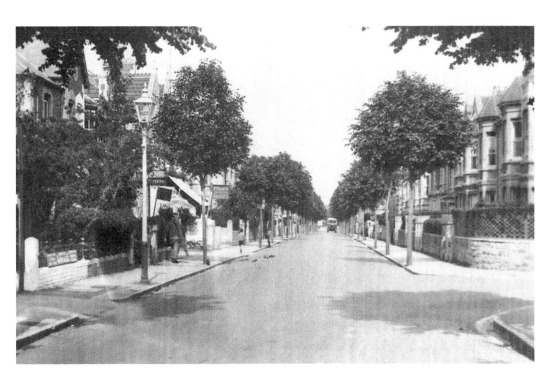

Moorland Road

Typical housing of the former Whitecross Estate. This view is from the junction with Lyndhurst Road towards Devonshire Road. Phillip's Bakery is on the left, and next door was a small garage. It is interesting to note the variety of shops and services that were available in this suburban area centred on Moorland Road, Severn Road and Whitecross Road.

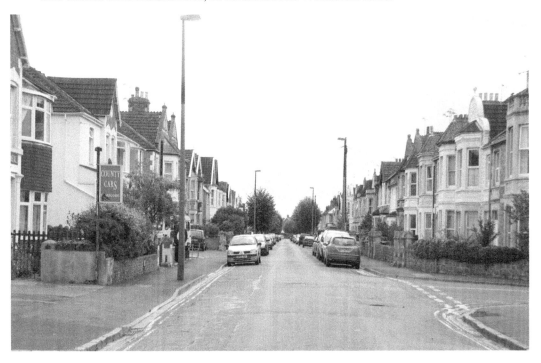

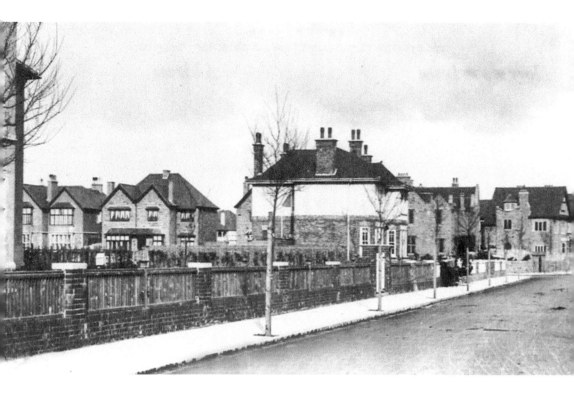

Brean Down Avenue
On the edge of the old Whitecross Estate, Brean Down Avenue presents a broader variety of later architectural styles and more open spaces then the terraces nearer the town.

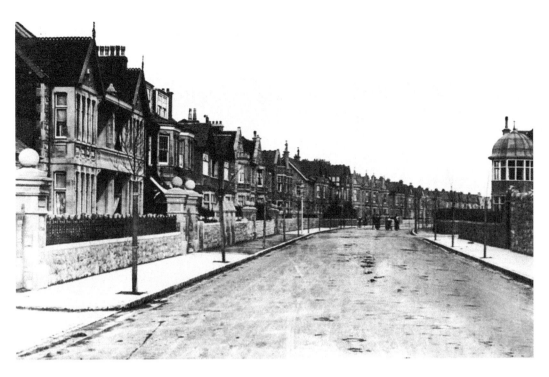

Charlton Road

Sedate suburbia. There is a strong sense of social aspiration in the older photograph with the sweeping curve of the dignified homes. The trees have been recently planted, and the local inhabitants can walk along the middle of the road as there is not a single motor vehicle in sight.

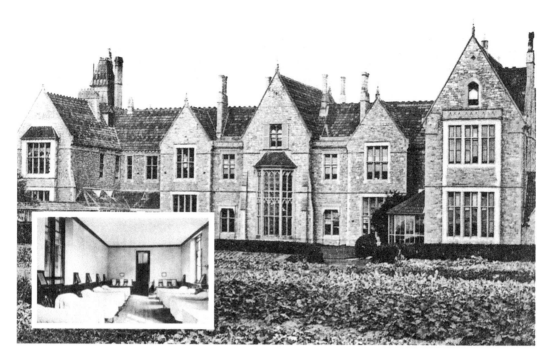

The Royal West of England Sanatorium

This splendid building has dominated the seafront since 1868, when it was built by public subscription at a cost of £15,000. Hans Price played a part in its design. It was intended 'for convalescents of the working class', and was later used in several roles by the NHS. The original wards (*inset*) were very formally structured.

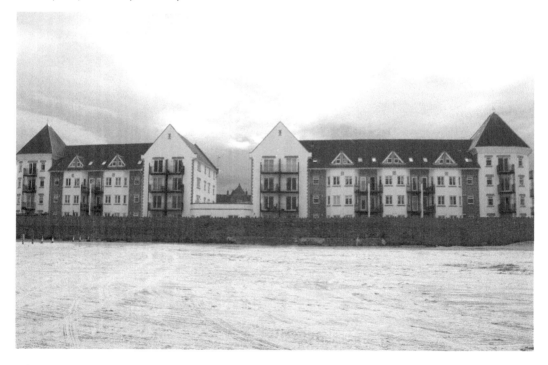

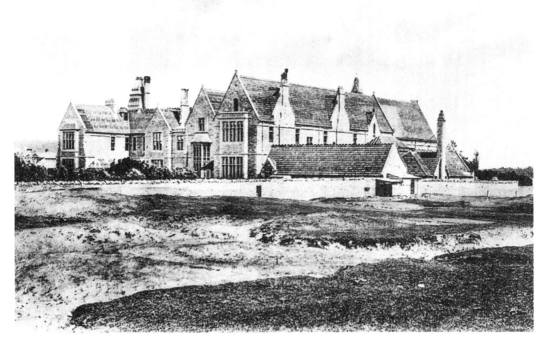

The Sanatorium from the Golf Course

The Sanatorium has been converted tastefully into apartments in a gated community, and includes new buildings near to the beach. The earlier view is from the golf course.

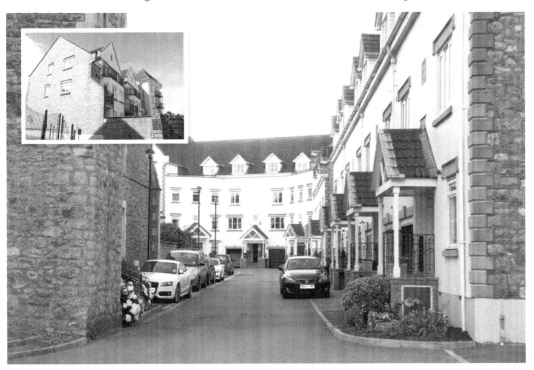

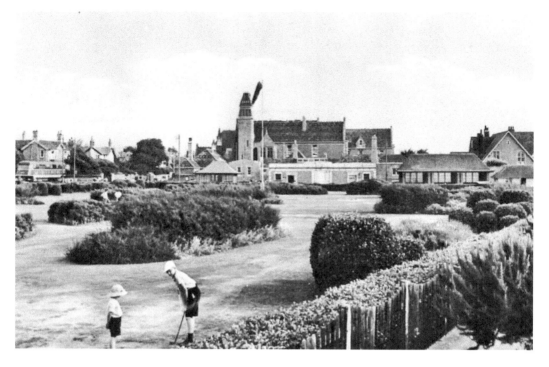

The Promenade and Putting Green

The well-maintained shrubs and borders add an air of civic pride to this view of the putting green near the Sanatorium. The advertisement on the Bristol Omnibus double-decker is for 'George's Beers'. A 7.25-gauge miniature railway now operates on a circuit around the green.

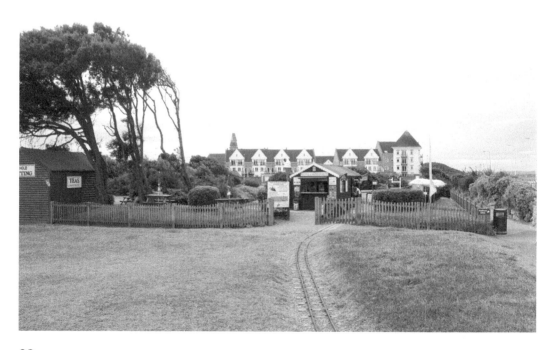

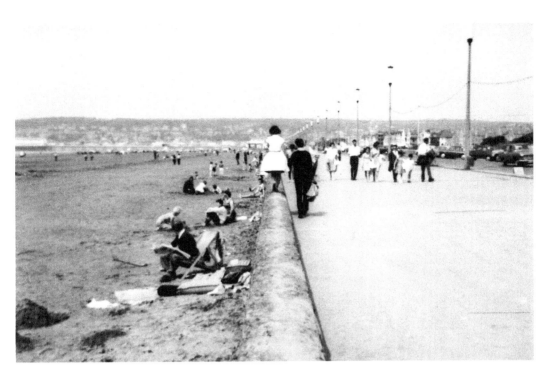

The Promenade Looking North

The Sanatorium marks the southern end of Weston's fine sea wall and promenade, and is where the tramway system ended. It has always had a quieter and less-commercial nature than the centre of the resort in the vicinity of Regent Street and Oxford Street.

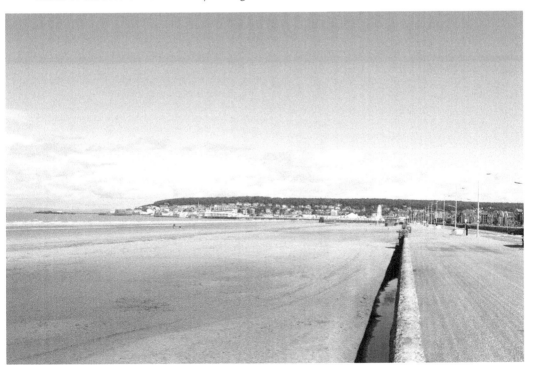

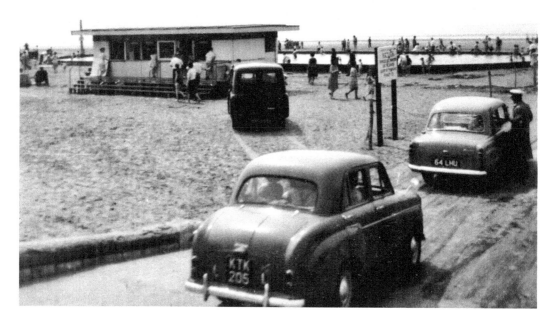

The Boating Pool

Visitors arriving by train would most likely reach the promenade near the Grand Pier. Those coming by car could (and still can) park on the beach. This photograph dates to 1963, when the small family car was coming into its own.

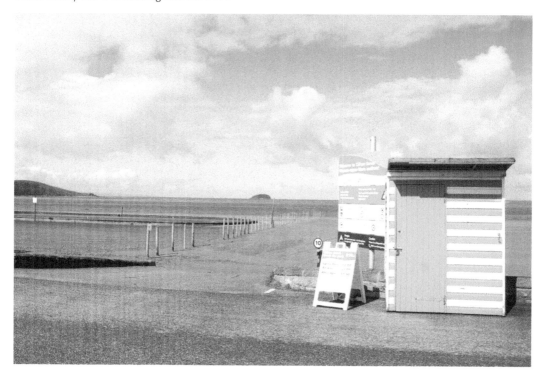

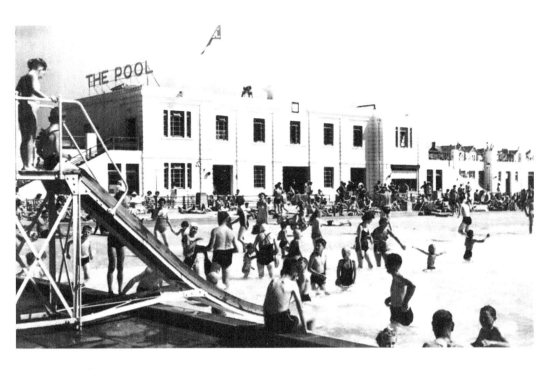

The Pool

A long and lingering problem for Weston has been the demise of its Open Air Pool. It was built by the town council in 1937 with an impressive 10-metre-high diving stage. It could accommodate up to 1,500 swimmers and bathers as well as spectators. The diving stage was removed in the 1980s and the building was restyled as the Tropicana. On the roof was an air-raid siren, later used to call out the lifeboat to aid vessels in distress in the Bristol Channel.

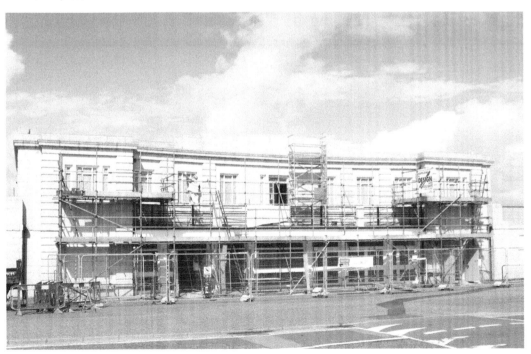

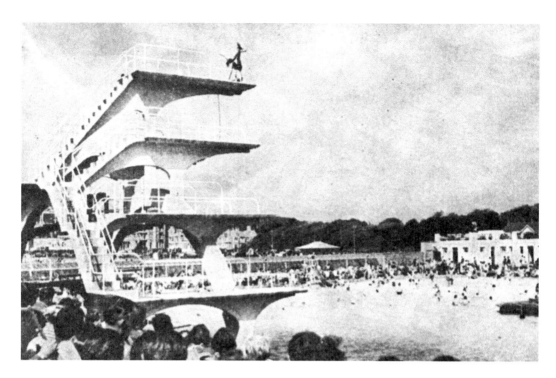

The Pool

The Tropicana closed in 2000. Twenty-first-century holidaymakers needed a facility which could be used every day, and not just when the sun was shining. A lack of investment had meant the art deco fabric of the building had declined. After several failed projects, work finally began in 2015 to renovate the seafront-facing section at a cost of £400,000.

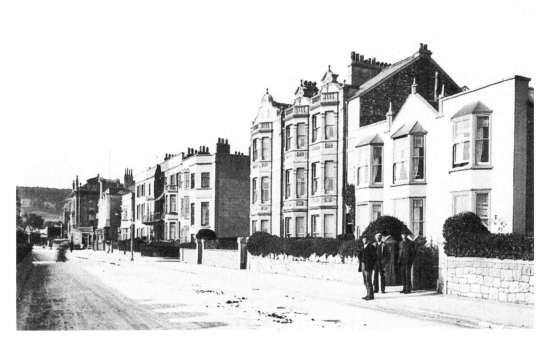

Beach Road

Dignified houses lined the Beach Road from the centre of the town south to the Sanatorium. This photograph is undated but would appear to be from the 1950s. From about that time, Weston became a favoured location for business and church-owned retirement and convalescent homes. A significant number of Beach Road houses were consequently converted, extended or demolished.

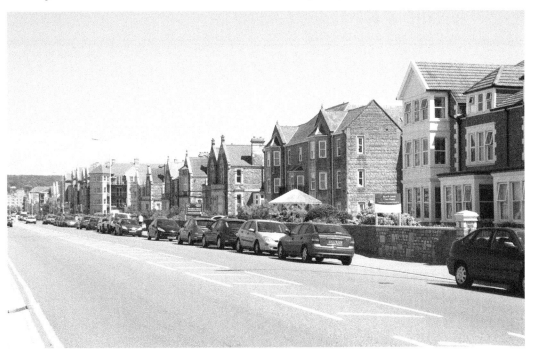

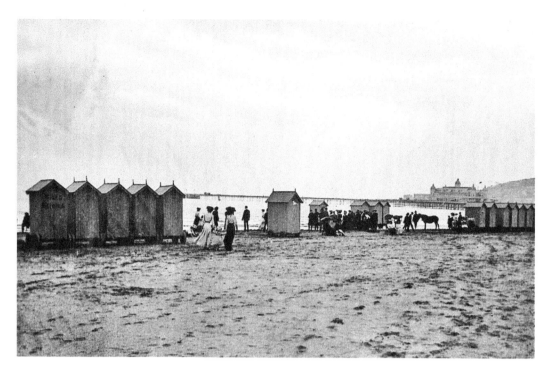

Bathing Machines and Beach Huts
In the 1920s, 'machines for ladies and gentlemen' were stationed on the sands and mixed bathing was permitted. In 2015, colourful beach huts were introduced. The first to be purchased was sold for £2650.

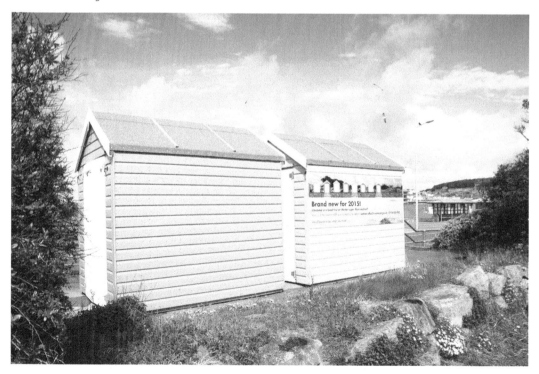

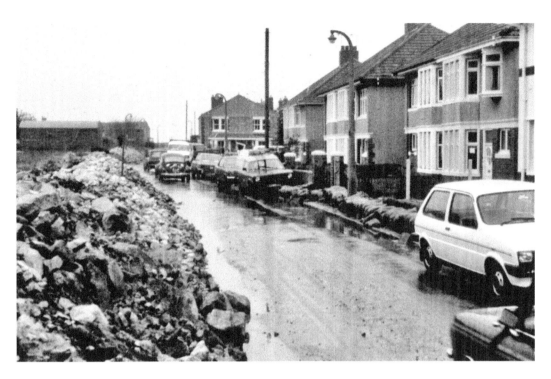

Uphill Links Road
From the Sanatorium south to the mouth of the River Axe stretches a mile of sand dunes and the golf course. Uphill village is protected from flooding by a complex drainage system, but the storm of December 1981 wreaked much damage.

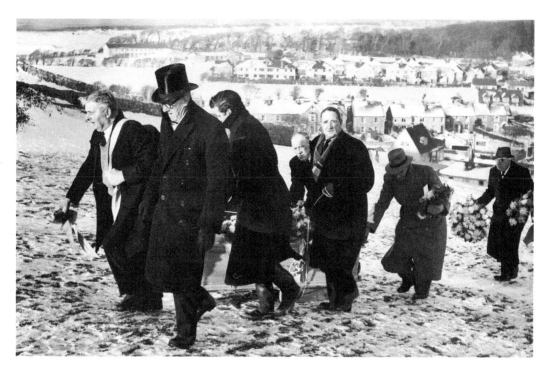

A Funeral at Uphill

From the entire length of Weston's promenade, as far as Birnbeck to the north, the partlyruined church of St Nicholas can be seen high up on the hill. It was built in 1080, and is now in the care of the Churches Conservation Trust.

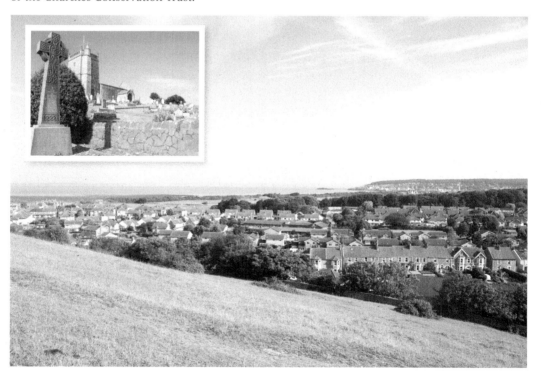